WATERFALLS
pages 46, 47, 48, 49, 50, 59

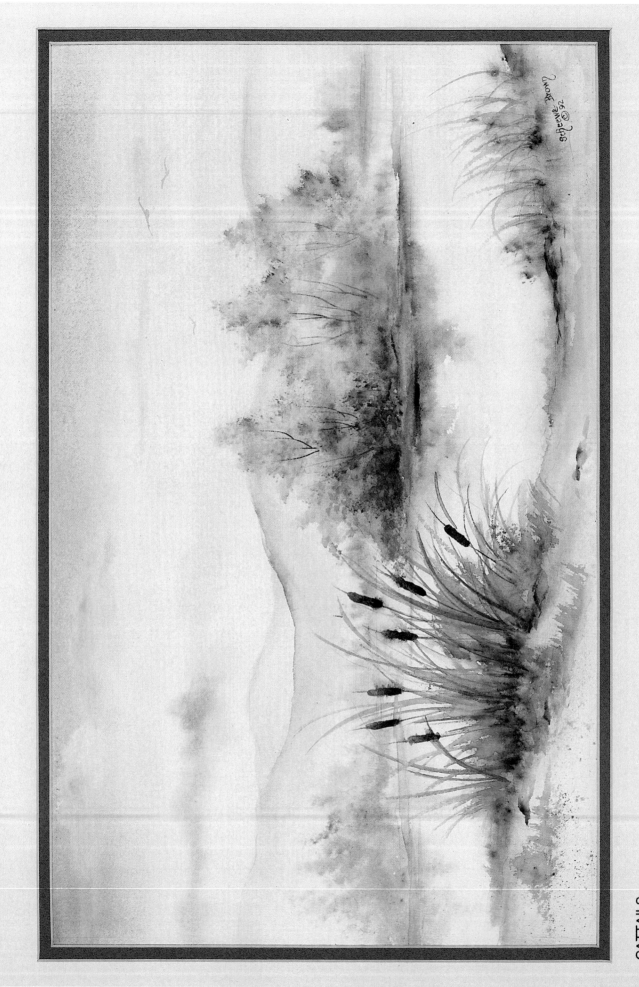

CATTAILS
pages 82, 83, 84, 85

SUNRISE - SUNSET REFLECTIONS
pages 96, 97, 98, 99, 100

SPATTERING ON A
WET SURFACE

SPATTERING ON
DRY PAPER

HARD EDGE

GLAZING

SOFT EDGE

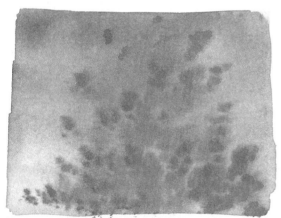

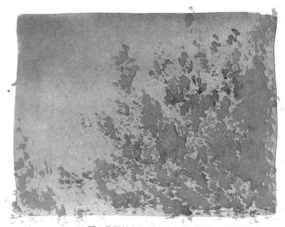

TAPPING ON WET SURFACE

TAPPING ON A DRY SURFACE

BLOOM, BACKRUN, WATERMARK

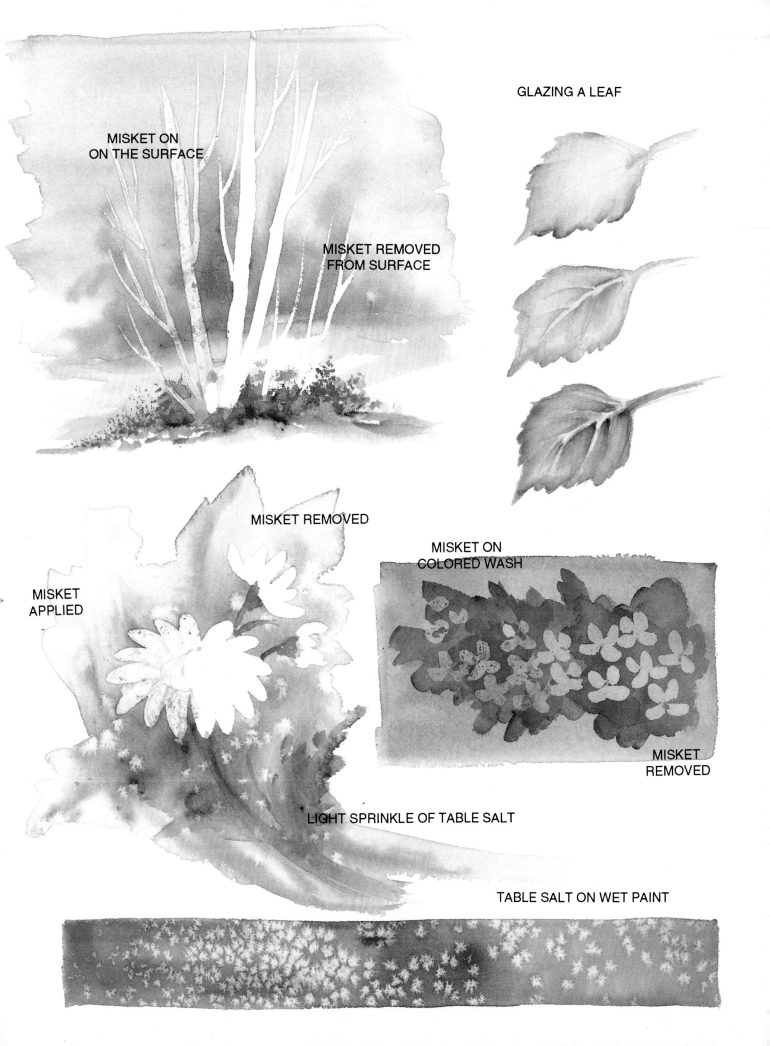

GLAZING A LEAF

MISKET ON
ON THE SURFACE

MISKET REMOVED
FROM SURFACE

MISKET REMOVED

MISKET ON
COLORED WASH

MISKET
APPLIED

MISKET
REMOVED

LIGHT SPRINKLE OF TABLE SALT

TABLE SALT ON WET PAINT

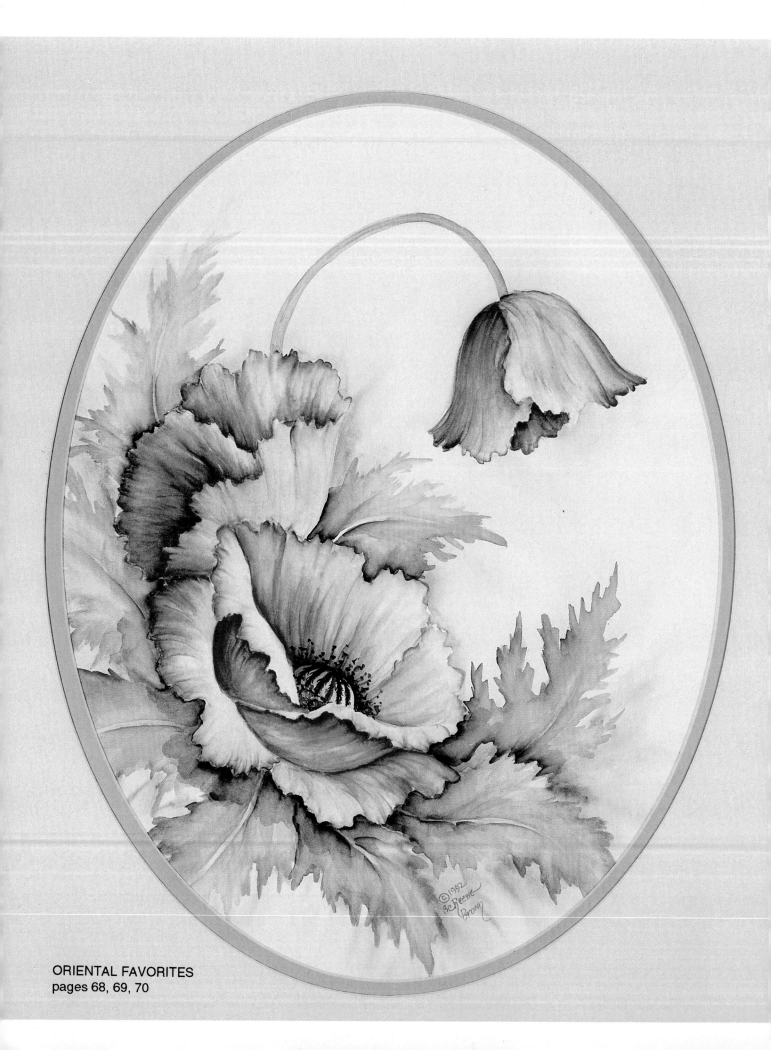

ORIENTAL FAVORITES
pages 68, 69, 70

Susan Scheewe Brown has enjoyed painting and teaching for the past 26 years. Sue has traveled and taught in the United States, Canada, Germany and New Zealand. It is seldom that a person finds a career that brings so much satisfaction. She writes and publishes books on painting, teaches seminars, travels to many trade shows sharing her love of painting.

I hope the pages ahead will provide encouragement and positive reinforcement for you. I've tried along the with my daughter Camille's help to pass on to you what I've learned over the years. I've grown, made mistakes had up days and days when the paintings were not just what I planned, but I've loved every minute of it! I hope you'll share with me the joy of painting watercolors.

I have completed the third "Gift of Painting" series for P.B.S. . The entire third series shows a variety of watercolors. Many of the paintings in this book where shown step by step in series three. Call or write your P.B.S. station to request information on when the shows will be aired in your local area. You can purchase copies of these programs from WMHT TV, 17 Fern Avenue, Schenectady, N.Y. 12306, or contact them by telephone (518) 356-1700. I hope this book and the television series will help you better understanding of some different ways to approach watercolor. Try to focus on your success and not your frustrations as you learn more about this medium.

Especially for those of you who are just starting to paint, keep in mind everything you do is a learning experience and that is how you will grow. Each new technique you conquer brings its own separate satisfaction.

The following is a listing or our superior national teachers:

Darlene Curtsinger
18 Forrest Oaks Drive
North Little Rock, AR 72120
(501) 834-4491

Jane Drynan
9551 South Vanderpoel Ave.
Chicago, IL 60643
(312) 445-8677

Eileen Griffin
4 Karen Lee Lane
Tewksbury, MA 01876
(508) 851-4186

Bev Hink
9342 N.E. 76th Street
Vancouver, WA 98662
(206) 892-6825

Charleen Stempel
c/o Balance Sheet
101 South 7th
Frisco, CO 80443
(303) 668-3515

Barbara Smith
911 West Summit
Fergus Falls, MN 56536
(218) 736-3572

Ros Stallcup
1436 Lakeview Drive
Virginia Beach, VA 23455
(804) 464-4974

Carolyn Stevens
P.O. Box 81
San Mateo, FL 32187
(904) 328-6832

The staff has been selected because of their excellent teaching ability as well as their beautiful personalities. I'm sure you would be delighted to participate in one of their classes. The staff comes to Portland for training and take not only classes from me, but authors such as Donna Bell, Jean Green, Ellie Cook, Don Weed, Carol Binford, Jackie Claflin and Gene Waggoner.

Most all of our authors give workshops, you can write or call them directly for information.

During the summer we will be having a week-long watercolor class. Please write Susan Scheewe Publications for details.

SUPPLIES

Each painting lists the colors and brushes I've used to complete the painting. Rather than listing all the colors and brushes used in this book, I feel you can select those to fit your painting needs. I use Academy Watercolor by Grumbacher which should be easily available for you to purchase. I've used several different papers – 140 lb., 260 lb., and 300 lb. cold pressed paper by Westport, Winsor Newton, Lana and Arches for a painting surface. A variety of brushes have been used depending on individual paintings. Use a plastic watercolor palette to load and reload your paint; if you don't have a plastic palette with wells, a Hyplar paper palette will work or a dish.

MISKIT – LIQUID FRISKIT BLOCKING AGENT

Some watercolorists feel a certain dislike for masking methods regarding it as cheating. Believe me the use of a Miskit-Friskit is very helpful and makes completing a painting far easier. By using Miskit-Frisket, you can protect one part of the surface while working on backgrounds. If you plan a painting that requires small areas, intricate highlights or shapes to be saved, this is an answer to your problems. When the painting of a particular area is complete, the masking is removed.

CAUTION – Prior to placing the brush into the masking fluid, dampen the brush, then rub your brush against a bar of soap; this will protect the hairs of your brush from being damaged by the Miskit-Friskit. Repeat this step frequently leaving soap on the brush while using the Miskit. Once you are done applying Miskit immediately wash the brush in warm tap water to completely remove the masking fluid. Miskit has a soft peach color, it will not stain the paper, it is only tinted so you can easily see where it has been applied. Allow the Miskit-Friskit to dry completely before going on to the next step, it will feel rubbery. DON'T try to speed the drying with a hair dryer as the heat could bond the Miskit to the paper surface. The orange color settles to the bottom of the jar, stir the jar to pick up color, DON'T shake it as it causes air bubbles.

CAUTION – Some papers could be too soft and when you remove the Miskit it could shred or tear the paper. Since different papers vary, it's a good idea to always test the Miskit on a scrap of the same paper you intend to use (you shouldn't have any trouble with Westport, Winsor Newton, Lana or d'Arches 140, 260, or 300 lb. cold pressed). Problems could arise if you remove the Miskit while the area around it is not completely dry. The paper surface should be COMPLETELY dry before removal.

The masking fluid should be removed very gently. Use either a rubber cement eraser or a small piece of masking tape to lift off this material slowly, do not rip quickly. Don't press the masking tape hard on the surface as it would damage surrounding paper.

Using the Miskit really is easy but a few more tips.

Don't leave it in the car in the Winter as freezing could turn it to a jar of rubber, as I discovered one day. Don't place the bottle in an area that Summer sunlight can bake it also into a rubber ball. Don't leave it on your surface for weeks, if you can't complete a painting for several weeks, remove it and come back later with another application.

TRANSFERRING PAINTING GUIDE

Sketch on or transfer a painting guide to tracing paper. Position the tracing paper on the watercolor paper, secure the top corners with a small piece of masking tape. Slip a sheet of Saral graphite between the tracing paper and the surface. Lay a clean sheet of tracing paper over tracing guide and use a ball point pen as the uniform pressure is helpful plus you can easily see the area you need to transfer. NOT all graphite paper works, some have oil and could cause the paint to bead up. Should you be unable to find Saral go over the backside of your tracing guide with a soft graphite pencil and make your own transfer paper.

BE CAREFUL you don't press too hard when transferring a painting guide as it could damage the surface.

You may also just want to lightly sketch directly on the surface. As a word of caution, if you need to make an eraser correction, use a soft PE-1 eraser.

ERASING

You can remove unwanted transfer marks using a soft PE-1 eraser. Don't rub really hard using an eraser as you could damage the surface. Most often the eraser on the end of a pencil is too hard and could also damage the surface. Never erase while the paper is damp as it is very easy to damage the surface.

Once the painting has completely dried, you could come back and very lightly remove graphite lines you missed. Leaving a few pencil lines is fine but if they bother you – take them off carefully.

MATS

Mats are important in accenting any watercolor. Try several different variations of colors to see the mats that you like best.

I like to keep several mats handy as I paint. Mats by P.A.L.-Prime Art Limited are protected by shrink wrapping that have a see through center. The shrink wrap protects the mat surface from being damaged by paint or accidental dirty fingers while you work. These PAL mats come in a large range of he most popular sizes and colors. For more information you can write or call them directly.

PAL - PRIME ART LTD> INC.
8911 Rossash Road
Cincinnati, Ohio 45236
FAX (513) 793-2318

PAPER

The type of watercolor paper you select will definitely affect the outcome of your painting. You will find painting far more enjoyable if you are not fighting the surface. Knowing what a paper will or will not do can greatly help your painting and eliminate your problems. The 140 lb. cold pressed will be easier for those just learning, it's also not as expensive as the 260 lb. or 300 lb. The average sheet size is usually 22 x 30 but sizes can vary by some brands. You can purchase papers in pads, blocks or sheets.

Be careful to store your paper in a safe dry area. Moisture from the atmosphere can absorb into the paper.

One of the advantages of sheets is that they can be torn or cut into many sizes. Fold the paper back and forth till it begins to break.

I've discovered how much I like, for many of the paintings done in this book, working on 260 lb. cold press Winsor Newton. The paper worked very easy holding the water allowing me to work at a comfortable pace.

Try the same small painting on several pieces or types of watercolor paper. You'll soon make your own discovery for those qualities each paper has a character. You'll find some easier to control, which take more abuse and repeated handling.

Place in your watercolor notebook the different types of paper. You might slip in notes you've made with the paper for reference at a later time.

WASHES

Washes are diluted applications of paint. A graded wash is a wash which makes smooth transitions from light to dark values. Flat tone washes are even value and color. A wash laid on dampened paper has a soft diffused quality. Applying a wash to dry paper requires much faster work.

PRE-WET

A term used for wetting an area of paper with clean water before applying any paint. This process will allow you to blend your colors easier, and work the panit longer on the paper. I use this often as I prefer the working time it allows me as I apply color.

WET-IN-WET

A process of adding paint into a wet area that already has been either pre-wet with clean water, or using a brush with both pigment and water.

The blending or diffusion of color in the wet area depends upon the amount of water and paint in your brush when applying it to the paper surface. There is always the potential for backruns if the paper isn't evenly wet. Don't leave puddles of water to avoid backruns. Some artists soak the paper completely before painting, I most often pre-wet sections.

BLENDING

A gradual transition from one color or tone to another. The graduation of color is far easier to achieve when working wet into wet so the colors flow into one another. To avoid a hard edge being formed, quickly apply clean water at the edge of the last stroke.

DRY BRUSH

This technique is just what the name implies – using a brush that is almost dry. The almost dry brush will skip across the surface of the paper so the color partially covers the paper. This is very helpful in creating the appearance of texture.

Be careful to dilute the paint a little while the brush is slightly damp, you do not want to apply straight pigment. Practice on a sheet of scrap paper, too much water and pigment will make a blob and too little or dry doesn't work well either. Make sure the underpainting is dry or the colors will diffuse.

SPONGES

Sponges are wonderful to have to reach for mopping up unwanted paint or moisture. For quick clean up, it's a great tool. Sponges are also helpful to apply the appearance of texture or applying flat large washes.

Dabbing the paint onto paper with a sponge gives an attractive mottled effect. With the many varieites of sponges it's nice to have several sizes and shapes to create special effects. Small natural sponges are excellent to create the appearance of foliage or, dab on a rock shape to create the appearance of texture.

If a sponge is used really wet the colors will tend to blend together. A damp sponge will give a more textured appearance.

SPATTERING

The flicking of paint onto the paper can create the appearance of rocks on a bank, sand on the beach, snow, spray in a waterfall, only to name a few ideas. Spattering often adds the appearance of texture creating more depth in a painting. Practice on scrap paper to see how diluted you want your paint.

BLOOM

A bloom, backrun, watermark or flower are all words that describe the appearance of a mark or area that dries unevenly on the paper. It is a personal thing if you like this appearance or not, some painters do these deliberately. They are most often caused by placing a very wet brush into a damp area which moves the pigment creating the watermark or bloom. To avoid this try to work wet into the freshly wet area or wait until the surface has completely dried and then continue on. Always wipe off excess water on your brush before picking up paint.

If you start to get a backrun, act quickly and try to even the moisture on the surface. You can lift off some of the excess pigment with a dry brush.

SCRATCHING

You may want to scratch into wet paper to create twigs, grass, distant trees, or birds. When you scratch with the handle of the brush this may be a creative technique. Practice on scrap paper to see the many effects you can achieve.

ACCIDENTAL SCRATCHING

The paper can be damaged prior to painting by an accidental scratch from a ring or sharp object. This can create a problem in your finished painting. Be sure to check your paper prior to starting. The paper in a scratched area pulls more pigment and will make a dark appearing line.

DRYING

The drying time can be affected by paper, pigment, temperature, humidity, and air circulation. All sorts of elements can affect the drying time.

Should you live in a very high humidity area you will want to watch that mold does not grow in standing watercolor palettes. Should mold appear wash the entire palette, wipe and wash with Pine Sol, rinse and start again.

Should you live in a very dry area and the paint is drying so fast you can hardly handle it, add a few drops of glycerin in the water.

SPRAYING

Having a fine mist spray bottle is a very handy item. Often after the paint has set on the palette overnight I'll spray it with water prior to starting my painting.

A spray bottle with clear water is also handy to mist a background. Be careful not to have a heavy sprayer as it could result in uneven water drops.

LIFTING OUT

Removing paint from the paper can be a very helpful painting technique. You could pat a wet sky area with a sponge, soft paper towel or brush to create clouds. You can lift off pigment with a brush to create veins. You'll think of many ways you can use this technique.

Should an area dry darker than you planned once dry, you can dampen the area and blot with a dry paper towel to lift paint. Some colors are more difficult to lift out as they stain the paper, such as Sap Green. If you plan to lift out colors, try them on test paper first. You'll also find some papers make it very difficult to lift off color.

HARD AND SOFT EDGE

This is just what it sounds like. Rather than having hard line areas along the edge you can dampen to create a blending or soft edge. Using both hard and soft edges gives a more realistic appearance when painting along with being very eye appealing.

COLOR CHARTS

It's very important to make color charts if you are just starting to do watercolor. Cut 8x10 sheets of watercolor paper to be later placed in plastic sleeves in a notebook.

Label the brand, color and type of paper you test the colors on. Start with strong pigment and dilute it as you work across the sheet with water to show gradation of color. The sheets become a valuable reference.

FOLIAGE BRUSH

This is an angular bristle brush that is wonderful to create foliage. Place the brush in the water for a few minutes prior to use if you are just starting to do your painting. The water will fill the bristles making the brush flair. Tap off the excess water on a paper towel, dip it in pigment, then on a test sheet of paper check for color and the amount of water in the brush. If the brush is too wet the color will blob together. If the brush is too dry almost no pigment will come off. With a little practice this will fast become one of your favorite brushes.

You'll soon discover you can use several colors on the brush at once to create variations in foliage areas.

TERMS

SALTING

Fascinating effects can be achieved by LIGHTLY scattering salt crystals in wet paint. Make an 8x10 sheet for your notebook testing salt on different colors. You find some colors stain the paper and hardly lift while others work wonderfully. Paper also makes a great deal of difference, the dampness of the paper and the type of salt.

The salt absorbs the paint creating light uneven spots. These can appear as snowflakes, small flowers in a bouquet, the appearance of texture in a background, so experiment. Most often the wetter the wash the larger and fainter the shape will be. Once the surface becomes dry, salt will not affect the surface.

A common mistake is placing too much salt on the paper the first time. Give a few minutes for the salt to dissolve in the pigment. Don't use a hair dryer as it could push the salt around. Natural drying time gives the best results. Allow the surface to dry completely before you brush off salt.

GLAZES

Glazes are easy to accomplish using just a little patience between steps. You must let each wash dry completely before applying the next transparent layer of pigment. Glazing is applying thin layers of diluted pigment over the top of another dry layer, allowing the bottom color to show through slightly and alter the appearance of the prior application. It's much like making layers of cellophane or stained glass, once laid over each other the appearance changes. An example would be taking yellow and overlaying with red, it would result in the appearance of orange.

It is extremely important as always to allow each layer to dry completely. Working on a different area in a painting or on another painting will give time for this to dry. While you could speed the drying with a hair dryer, DON'T turn it on full blast close to the paper as it could move the pigment. Don't use a hair dryer in combination with Miskit as it could cause the Miskit to bond to the paper and make removal difficult. Should you use a hair dryer be careful to wait for the paper to cool, warm paper would speed the drying process and make a hard line or difficulty in manipulating an even flow of color. Should you apply another layer before the first layer has dried the pigments will blend and alter the results.

Be careful not to scrub hard when you are layering colors as you again could cause blending or a blotchy result. Overworking an area could dissolve the wash below.

Glazing is a very important technique to learn while doing your painting. Keep a practice scrap of paper to test colors and layers before you apply them to your painting. Papers will also affect your results greatly, so make sure your test paper is the same type you are using to complete your painting.

COLOR REPRODUCTIONS

When you look at the book you should understand that there will be changes from the original colors in the painting to those you see in the book due to the mechanical reproduction and limitations of 4 color seperations. The pinks, lavenders and suttle values are often unfortunately changed or lost. While we work very hard to duplicate the original appearance, it is impossible to create some of the rich colors or pinks and lavenders in the paintings in this book. While the paintings can serve as a guide don't try to always color match.

HELPFUL HINTS

I've found while teaching, some areas that could be helpful as you learn more about watercolor. I've learned many of these helpful hints over the years sometimes by making a mistake and by learning from my mistake. I hope these hints will help you avoid some possible problems.

1. Make yourself a notebook. This notebook can be full of plastic sleeves containing color charts, tests using salt, special effects you've tried, sketches, papers and a reference as you experiment using watercolor and papers. Your notebook can be a wonderful source of material you have used, and knowledge to refer to at a later date. Include brush technique samples and special colors you've discovered that work well together.

2. Protect your paper prior to use. Be very careful not to damage the surface by accidently scratching the surface with your fingernails, bracelet or painting knives. Don't store your paper where items could come in contact to scratch the surface. Be extra careful around the family cat, it could accidently damage the surface with it's claws.

3. Don't place hand lotion or oil on your hands prior to handling the paper surface. This could create areas that repel the water.

4. Graphite papers can be helpful but many can create a problems due to oil or wax in the paper. I prefer Saral, as it works well for transferring my designs. Pencil can be used; allowing the pencil line to remain is permissible in watercolor. Removal of these lines can be done with a soft eraser. You may not find transfer paper available. An alternative is to rub a soft graphite pencil on the backside of tracing paper and then transfer to the surface.

5. Pencil erasers are most often too hard and can damage the paper surface should you rub too hard. Use a soft White eraser or gum eraser to remove unwanted lines.

6. Watercolors dry lighter than they appear when wet. There are several factors in how light a watercolor will dry, depending on the pigment, water and paper. As a good rule always go lighter and deepen the color slowly.

7. ALWAYS start with light pigment and deepen slowly as you will create far less problems for yourself, especially with pigments that tend to stain the paper.

8. Should you accidently splatter paint, immediately blot it with a clean soft towel or sponge.

9. Should you use a hair dryer to speed drying time, BE CAREFUL not to turn it on full blast next to the painting as it can cause the wet paint to move.

10. Be fair to yourself and use at least 140 lb. paper. It is easier to use a cold press paper verses using a rough paper.

11. When making greeting cards, buy the envelopes first and cut the paper to fit. Cards are fun to paint and a great way to practice your painting.

12. If sending a postcard remember to protect it from the elements.

13. Most often you wil not want to over scrub the paper. Over scrubbing a paper could damage the surface. Using a good 140 lb. paper will forgive some scrubbing, some of the more soft delicate papers can ball up.

14. Paint from light to dark. Some colors stain and are very difficult to remove.

15. Whatever you buy, the most important consideration is quality. The difference between poor brushes and paper and good material is the difference of making a painting a struggle or fun.

16. Keep a scrap of paper to test colors and occasionally a technique. Often you can save the test paper with notes and add it to your notebook.

17. Remember, when following instructions from the book; IT IS YOUR PAINTING so if you want to deepen, lighten or change colors you should do so. Color reproductions in print rarely appear exact to the original painting. Even when I do the same painting twice they rarely turn out the same.

18. Try to enjoy watercolors as you learn new techniques. We all have some days that just don't turn out how we planned. If you can gather a sense of humor on those off days it sure helps.

PAINTING ON WET PAPER

Pre-wet the surface of the paper using clean water. While the surface is lightly wet, tap on color. The wet paper will cause the pigment to diffuse into the moist surface. The more water on the surface the more the pigment will diffuse. As the paper begins to dry, using this same tehnique you get more defined shapes. Tilting the paper will cause the pigment to bleed in a direction.

CREATIVE SCRAPING

The appearance of rocks and tree branches have often been created by scraping the paper with the handle of a brush, while the surface is still damp, using the wet on wet technique. While the surface is "damp", not overly wet, press very hard pushing pigment to the side to create rock forms, or tree trunks. Hold the handle as shown in the photo, as you scrape the surface of the paper.

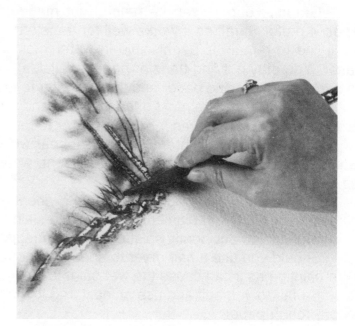

CREATIVE SCRATCHING

While using the wet on wet application of pigment, use the handle of the brush to scratch and draw on the wet surface. You will see the darker area appear very quickly, as scratched surface absorbs the pigment.

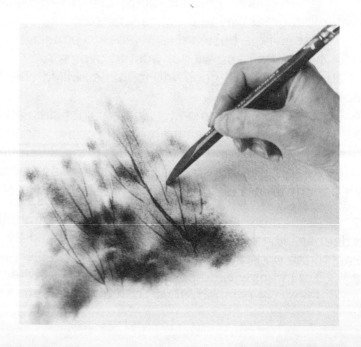

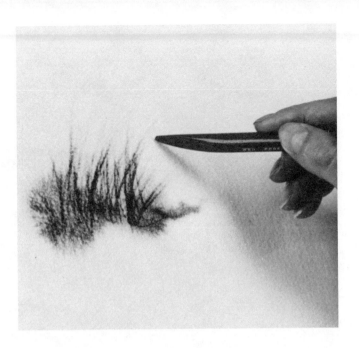

SCRATCHING AND PULLING PIGMENT

Use the wet on wet technique. While the surface is still wet pull up pigment using the handle of the brush. This is a very helpful technique when creating grass. It must be done quickly, as once the paper dries it is not possible to move the pigment.

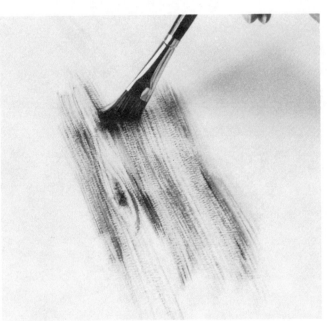

DRY BRUSH

This technique is just what the name implies. Using the foliage brush or an angular bristle, it is an easy way to create the dry brush technique. Use very little pigment on the brush, it should be almost dry, lightly drag the brush against the surface. This may be applied directly to the surface or, over a dry light wash to create the appearance of texture or wood grain.

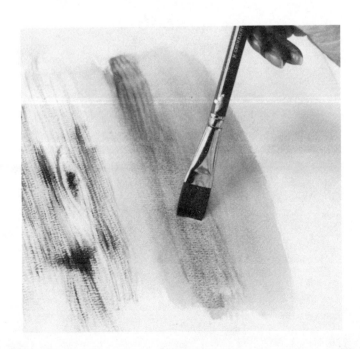

OVERWORKING DRY BRUSH

When using the dry brush technique, be careful not to overwork the area, or use the wrong brush. The area to the left shows good dry brush technique; while the one on the right shows an area that has been overworked, plus the use of an improper brush for this technique. Too much water on the brush can also cause the texture to blend together, appearing soft and diffused.

FOLIAGE BRUSH-LIGHT TAP

Prior to starting your painting, place the angular bristle foliage brush in your water container for 5 minutes. The water will cause the brush to flair making it very easy to create a small dot pattern. Lightly tap the brush against the paper to create the light texture of the foliage. This brush is easy to control when lightly tapping to create shapes.

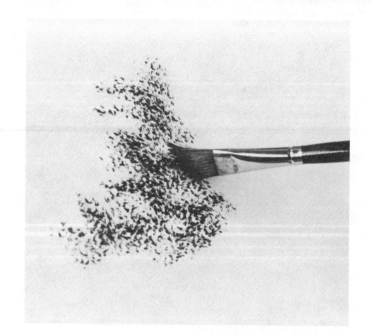

FOLIAGE BRUSH-WET BRUSH

Foliage can take on a different appearance by adding more water to the brush. This is especially helpful in the first light application of color. Allow the first application to dry, then build up thin layers of pigment with repeated applications.

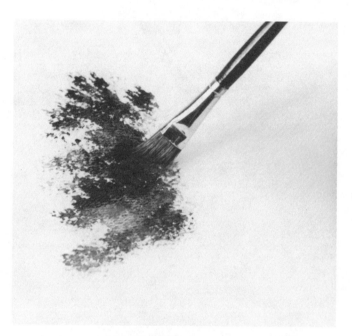

SPONGES

Sponges can be extremely useful when doing watercolors. You can lay on a wash, mop up unwanted water, and lightly tap to create the appearance of texture.

Lightly moisten the sponge, then dab it in pigment, tap the sponge onto the paper to create a nice mottled effect.

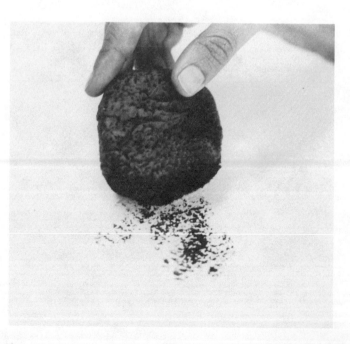

CREATING A GRADED WASH

You can control the gradation of color on a brush by adding more pigment to one side, and using less pigment on the other portion of the brush. This technique can be very helpful in creating dimension.

WET-IN-WET ON A DEFINED SHAPE

Pre-wet leaf, or flower shapes with clean water. While the pre-wet shape has a slight shine, pick up more pigment on the point of the brush and apply it to the shape. Because the paper is moist, the brush stroke will diffuse, eliminating an undesirable hard line in the middle of a shape. As you can see the entire brush is in contact with the surface, not just the point.

BRUSH LOADING

Very often, I only use the point of the angular brush in pigment. This is extremely helpful when you desire a gradation of color.

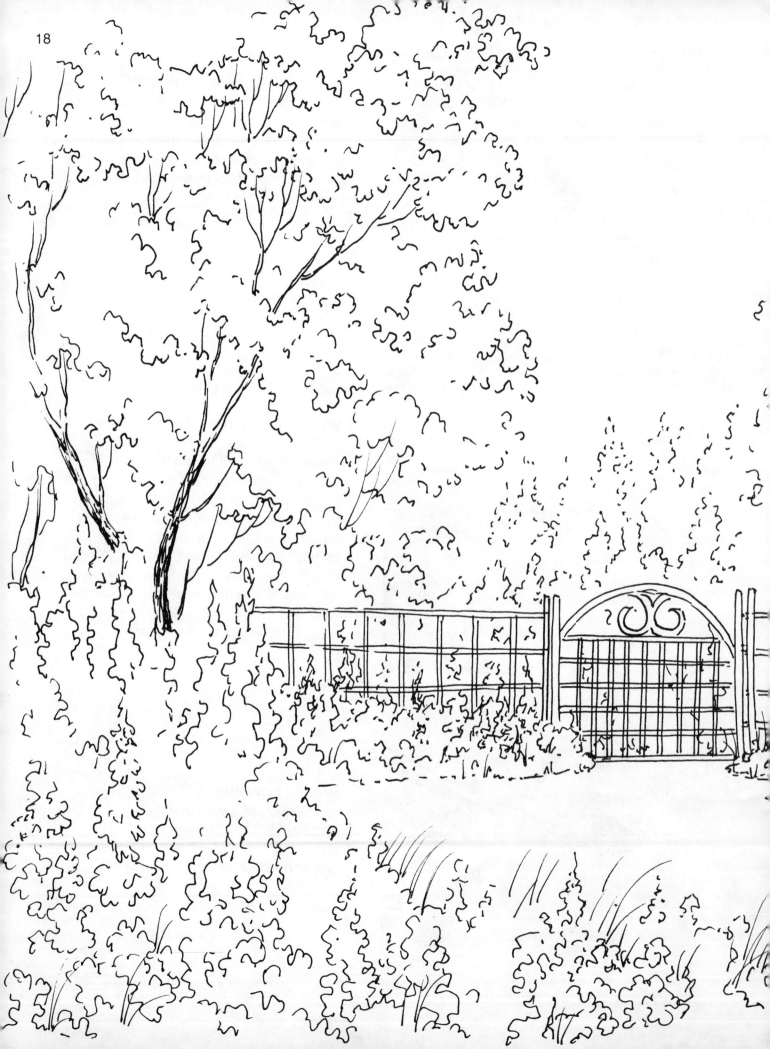

©1992
S. Reeve
Brown

GARDEN GATE

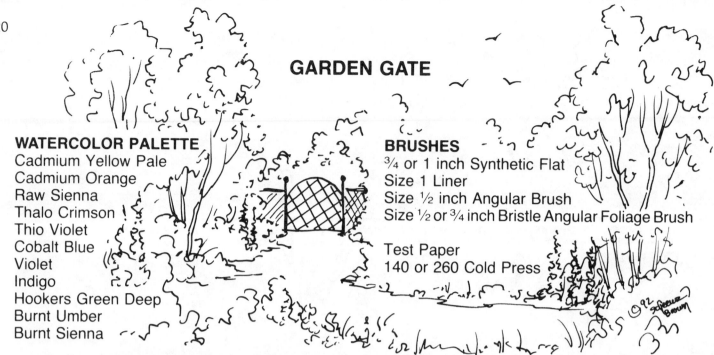

GARDEN GATE

WATERCOLOR PALETTE
Cadmium Yellow Pale
Cadmium Orange
Raw Sienna
Thalo Crimson
Thio Violet
Cobalt Blue
Violet
Indigo
Hookers Green Deep
Burnt Umber
Burnt Sienna

BRUSHES
¾ or 1 inch Synthetic Flat
Size 1 Liner
Size ½ inch Angular Brush
Size ½ or ¾ inch Bristle Angular Foliage Brush

Test Paper
140 or 260 Cold Press

Trace the pattern onto the watercolor paper with either Saral graphite transferring paper, or a graphite pencil. Be careful not to press hard when transferring the pattern as it is easy to dent the paper. If you do dent the paper, color will flow into the recess and it will show as a dark mark.

But, I would like to add that sketched pencil lines are often a part of traditional watercolor, it is all in what you prefer.

MISKIT

First you will need to apply Miskit to the gate. Be careful when using Miskit as it could ruin your brush with only one use. To prevent this use a bar of soap, wet the brush and stroke it back and forth along the bar until it lathers coating the brush with soap. Then dip the brush in Miskit, the soap will serve as a protective coating to the hairs. Clean the brush immediately with soap and water when you are finished. Use a liner to paint on the gate. Be sure the Miskit has dried completely before continuing on with the painting.

SKY AND BACKGROUND FOLIAGE

Begin with pre-wetting the sky area from the bottom of the gate up to the top of the page with a 1 inch synthetic brush. Start with a wash of Cad. Yellow Pale in the center area, from the gate upward. Then pick up a hint of Orange and apply it at the top, haloing the Cad. Yellow Pale and blending the edges. This Orange is a light application of color so do not paint it too dark.

Rinse the brush before picking up the next color. Pick up some Cobalt Blue and a touch of Violet on your 1-1/2 inch brush; test the color on a separate piece of paper to check the value before applying it to the painting. Then in horizontal strokes apply the paint to the top portion of the painting, arching from the left and to the right. While the sky is still wet you will want to tap in the faint suggestion of clouds with a light mixture of Thalo Crimson and Violet.

The next step is very important to finish while the sky area is still wet. Use your foliage brush to pick up some Hookers Green Deep, Cobalt Blue and a touch of Indigo, test the colors to make sure they are soft in value. Lightly tap on the distant trees behind the gate, leave bits of sky showing through the foliage. *IMPORTANT: do not bring the distant trees all of the way down behind the gate, this will make the pink of the flowers become muddy when they are painted. Look at the photograph.

While the sky is still wet, you will want to use the foliage brush to pick up Thalo Crimson and tap in the diffused flowers behind the garden gate. Tap in the area where the flower color is meant to be, or it will muddy the green tones when they mix too much. Look at the photograph.

This painting is built in a series of layers working from light to dark. So have patience in allowing the painting to develop.

Wash your brush, pick up some Hookers Green Deep, Indigo and Cobalt Blue and begin by tapping the foliage on the right side of the painting. Work the foreground area as well as the tree area; this is to be a light application of color that will diffuse into the wet sky area. Repeat the same on the left side, and along the bottom edge of the gate. We will paint the foreground later. Keep repeating applications of color, continuing to darken the tone. Be sure to leave sky area in the trees, and be aware to not create a solid mass of color, let the light reflect through.

PATH

Pre-wet all of the path area with clean water. Use your angular bush to pick up some Burnt Sienna and a touch of Raw Sienna, wash the color into the path area. To the right side of the path add a touch of Indigo to suggest a shadow. You will want to paint the path a bit wider than it is drawn so that it will blend into the foliage. When you paint on the foliage the path will tend to shrink as the edges fill in.

FOREGROUND FOLIAGE

Use your angular brush to pick up Thalo Crimson and tap in the foreground flowers. Look at the photograph for reference. Pick up a touch of Thio Violet, Violet, and Cobalt Blue tap in more flowers, you will also want to carry the color into the background area.

Next, pick up Hookers Green Deep and a touch of Indigo, tap in the foreground foliage. Be careful to not paint over the Thalo Crimson as the color will muddy. Keep adjusting the colors with layers of paint.

REMOVING MISKIT

Before removing any Miskit from the gate, the entire painting surrounding the area must be completely dry, or it will tear the paper. A trick to removing Miskit is to use masking tape to pull it off.

GATE

After the Miskit has been removed, use your foliage brush to pick up a diluted mixture of Violet and Indigo. You will want to place a clean test paper right against the painting next to the gate. Before tapping any color onto the gate you will want to test the value of it in relation to the rest of the painting and the gate. Look at the photograph to get an idea of where to apply the paint.

TREE BRANCHES

Use your liner to pick up some Burnt Umber, it should have a watery consistency so that it will create a nice clean line. If you look at the photograph you will see the branches are not connected the entire length up the tree, but they disappear in and out of the foliage.

As a final touch, use your foliage brush to tap in richer tones to the tree area if needed. You may also at this time want to deepen the values of some of the other colors.

Plus, use your liner with Hookers Green Deep and a slight touch of Indigo to pull some grass strokes out of the foreground foliage. Look at the photograph for reference.

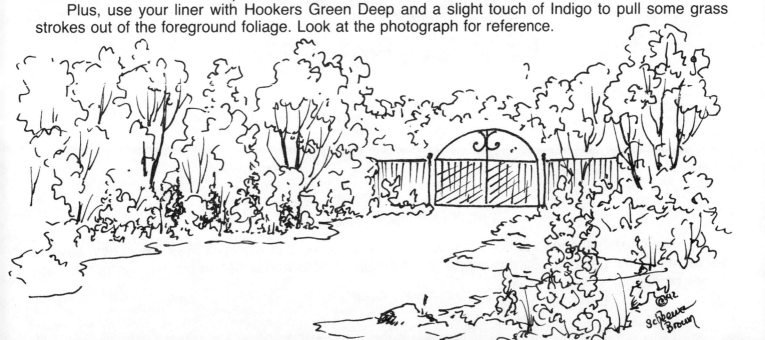

The garden scenes are beautiful, fun to paint, and some of my favorites. I've shown several variations of this painting. Start with one of the smaller pieces and continue on with one of the lush, larger paintings.

The many beautiful variations of the flower garden can be completed following most of the steps in Garden Gate.

FENCE

Because the fence is black you will not need to apply Miskit. Complete the flowers prior to adding the line work. Use a size 1 liner with Burnt Umber mixed with a hint of Cobalt Blue. Allow to dry completely, come back and highlight using a mixture of Chinese White and Cad. Yellow. Refer to the photo for placement.

GAZEBO

The gazebo is applied over the sky allowing some of the yellow to serve as a reflection of light. Lightly glaze on very diluted Burnt Umber using an angular shader and a liner. Add a very diluted glaze of Indigo more towards the left, post, and weather vane.

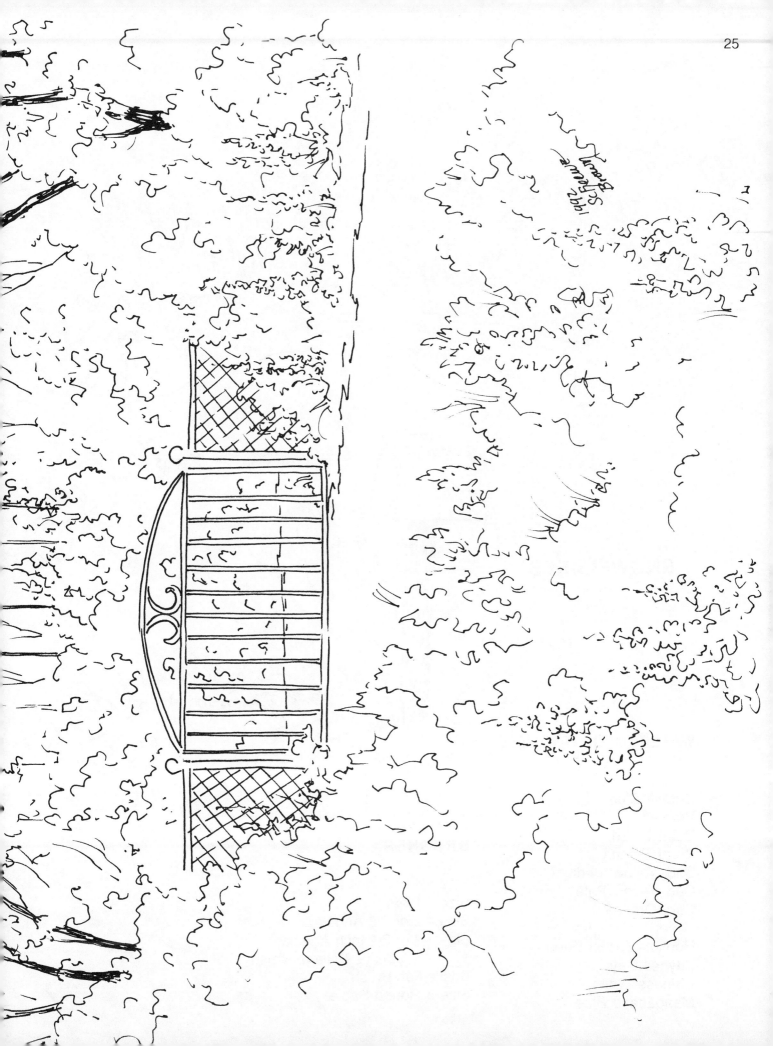

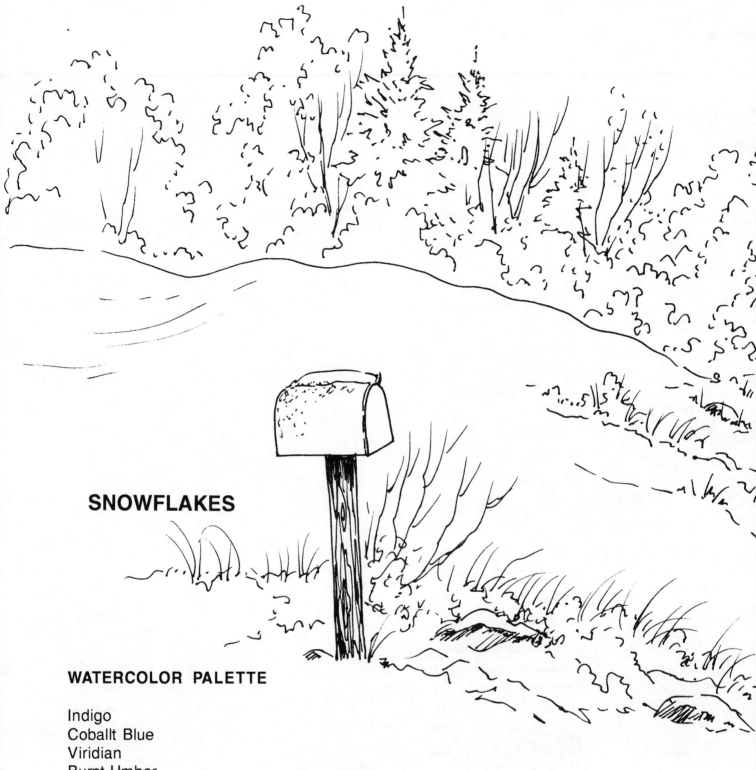

SNOWFLAKES

WATERCOLOR PALETTE

Indigo
Coballt Blue
Viridian
Burnt Umber
Burnt Sienna
Cad. Yellow Medium
Cad. Yellow Pale
Cad. Orange
Violet
Hookers Green Deep
Paynes Gay
Chinese White
Manganese Blue

BRUSHES

Size 3/4 or 1 inch Flat
Size 1 Liner
Size 1/2 or 3/8 Angular
Size 1/2 or 3/4 Inch Angular
 Bristle Foliage Brush
Bristle Fan Brush
Size 5 Round Sable

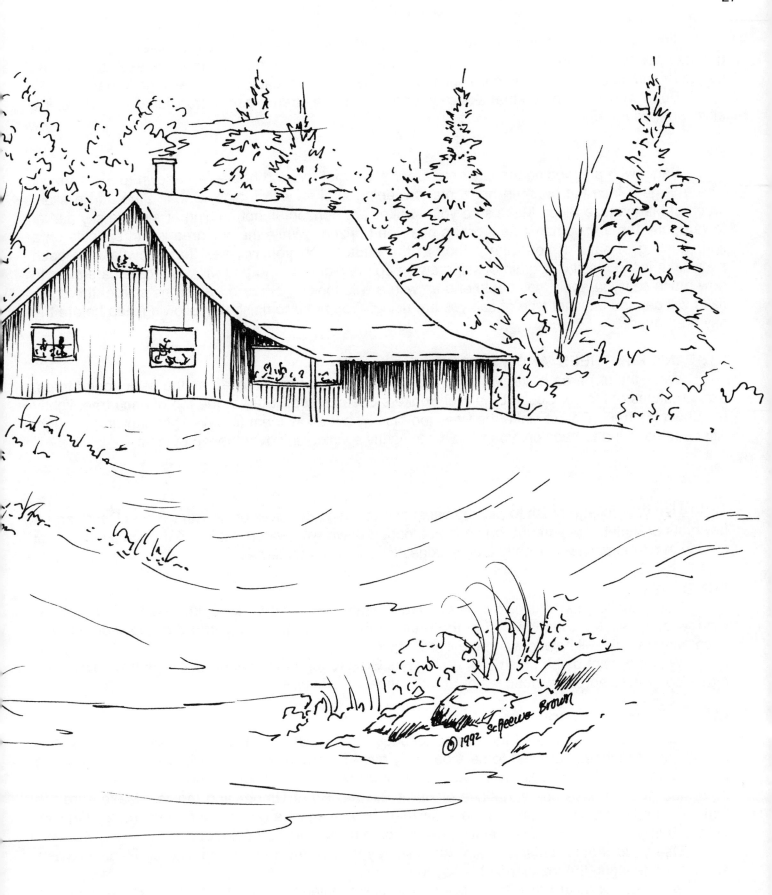

SNOWFLAKES

Trace the pattern onto the watercolor paper with either Saral graphite transferring paper, or a graphite pencil. Be careful not to press hard when transferring the pattern as it is easy to dent the paper. If you do dent the paper, color will flow into the recess and it will show as a dark mark.

But, I would like to add that sketched pencil lines are often a part of traditional watercolor, it is all in what you prefer.

SKY

Begin with pre-wetting the sky area around the roof top and house, and down to the horizon. Use a large 1 inch flat brush in horizontal sweeping strokes with Indigo, Cobalt Blue and a slight touch of Manganese Blue. Make sure your strokes are horizontal, not arching. Paint the sky darker towards the top and lighten it as it draws near the horizon. While the sky area is wet sprinkle on a light dusting of salt. If you take a look at the photograph you will see that snowflakes; each snowflake is the result of 1 grain of salt drawing up the pigment. So you will want to be careful as to how much salt you apply, you could end up with a wild looking blizzard. Also, the size of the snow flake will depend on what type of salt you are using. You need to finish the following step before the sky area dries.

DISTANT FIR TREES AND FOLIAGE

While the sky area is still wet use your 1/2 inch angular brush to tap on the background trees, use variations of Indigo, Cobalt Blue and Hookers Green Deep. Start at the top of each tree, lightly tap down the tree. Do not make the trees too blocky, but allow them to have light showing through. After you have the fir trees on, you will want to lightly sprinkle salt over the top of them.

Use your foliage brush to pick up variations of Indigo, touches of Hookers Green Deep, and a few hints of Violet. Be sure the brush is not loaded down with water, if it is the color will diffuse out too much on the painting. Lightly tap in suggestions of distant foliage.

WINDOWS

Use your angular brush to pick up Cad. Yellow Med. and Cad. Yellow Pale. Paint on the window shapes. Next load the tip of the brush with Orange and apply it to the upper portions of each window, this will help to warm the interior color.

With the point of the brush pick up Paynes Gray to tap in the shadows on each window. You may also want to add a few touches of Burnt Sienna.

HOUSE AND CHIMNEY

Use variations of diluted Indigo and touches of Burnt Sienna as a first application of paint to the house. This does not need to be a perfectly even flat wash of color; it will give the siding more texture and interest if the color is varied and a bit uneven. Shade lightly under the eaves. On the right side of the house use variations of Burnt Sienna, Burnt Umber and Indigo. Make sure the bottom edge, where the house and the snow meet is uneven, this will create a more interesting line. Let the house dry before adding details, we will come back to it in a later step.

Use your angular brush to paint the chimney with Burnt Sienna and English Red. Leave a sliver of white along the top of the chimney to suggest snow.

With your angular brush pick up a diluted hint of Indigo and brush the suggestion of smoke drifting into the sky.

On the roof paint a very light wash of Indigo with a slight touch of Cobalt Blue. Look at the photograph for shading and color reference. Also add a slight shadow along the roof trim on the far left slope.

LIMBS AND BRANCHES

Use your liner to pick up an ink like mixture of Indigo and water. Test your color on a separate sheet of paper before applying it to the painting. As soon as you have painted on each branch structure, come back in with a "dry" brush and lightly tap over it a bit to soften any hard lines. Look at the photograph for reference and placement.

MAIL BOX

Use your angular brush, pick up more paint on the point of the brush. Test your color on another sheet of paper first. Start by shading the left end of the mail box, add more water to lighten the color as you move forward. You may also want to add touches of Burnt Sienna to give the appearance of rust.

To create snow on top of the mail box use a touch of Indigo on the point of your angular brush. Shade the left edge of the snow mound, and lightly bring the color over to the right. Look at the photograph to get an idea.

Paint the post with Indigo and a touch of Burnt Sienna. Shade the post underneath the mail box, lighten the color as you paint downward.

GROUND AREA

With clean water and 3/4 inch flat synthetic brush, wet the ground area along the bottom of the trees, on both sides of the hills and along what would be a path. Wash in light shadows with diluted variations of Indigo, Cobalt Blue and touches of Burnt Sienna.

Use the bristle fan brush to paint the grass clumps with variations of Burnt Umber, Indigo, touches of Cobalt Blue and Burnt Sienna. Paint on the rocks with an angular brush using variations of Burnt Sienna and Indigo.

Then after the grass areas have dried use a liner to pull out blades of grass, add a few branches in the foreground. You may also want to add a few touches of Chinese White. Again, look at the photograph.

HOUSE

Detail the siding on the house with variations of Indigo and Cobalt Blue mixed with Chinese White, touches of Burnt Sienna and Burnt Umber. Use either a 5 round brush or an angular shader. Look at the photograph for reference.

As a final touch you may want to add Chinese White to some of the background branches and limbs. Once again, look at the photgraph.

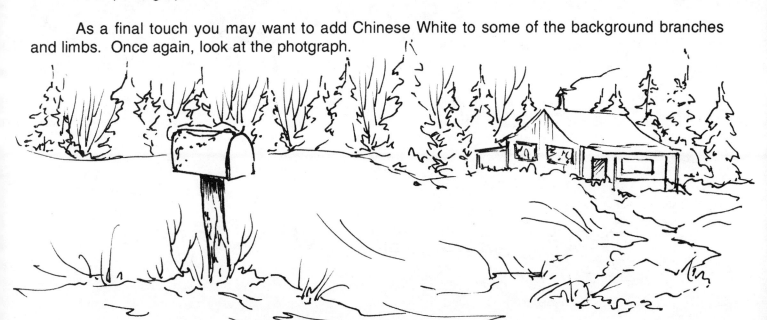

DISTANT FARM

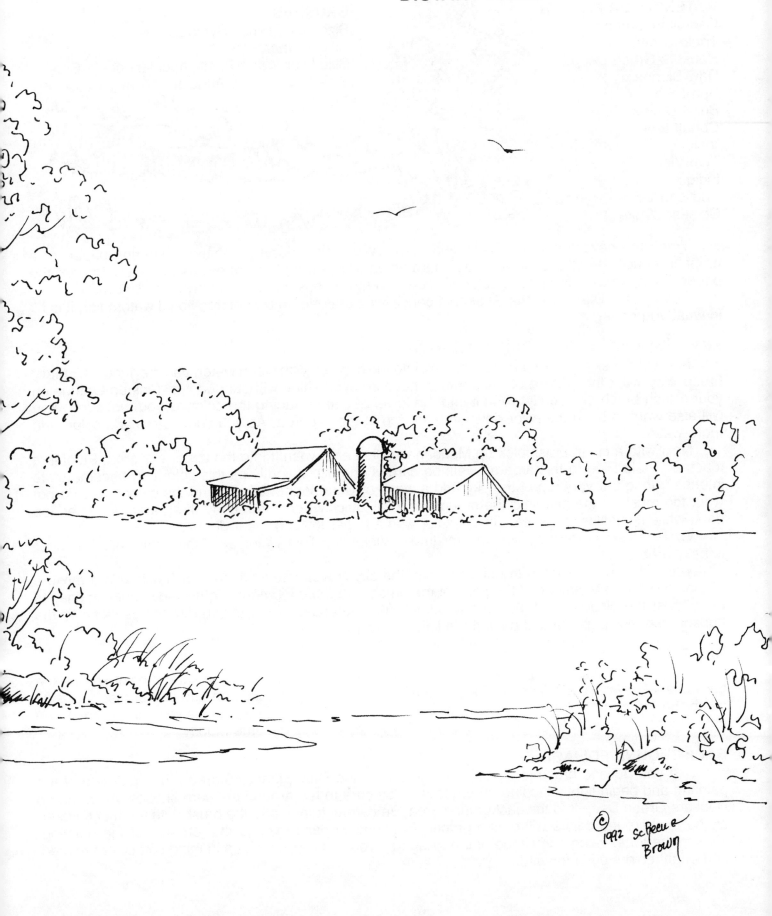

DISTANT FARM

WATERCOLOR PALETTE
Cadmium Orange
Thalo Green
Hookers Green Deep
Raw Sienna
Burnt Sienna
Burnt Umber
Cobalt Blue
Violet
Thio Violet
Indigo
English Red
Chinese White

BRUSHES
Size ¾ or 1 inch Synthetic Flat
Size 1 Liner
Size ½ or ¾ inch Bristle Angular Foliage Brush
Size ½ Synthetic Angular

Trace the pattern onto the watercolor paper with either Saral graphite transferring paper, or a graphite pencil. Be careful not to press hard when transferring the pattern as it is easy to dent the paper. If you do dent the paper, color will flow into the recess and it will show as a dark mark.

But, I would like to add that sketched pencil lines are often a part of traditional watercolor, it is all in what you prefer.

SKY

Pre-wet the sky down to the horizon and into the hill area with clean water, use the 1 inch synthetic brush. You want the surface of the paper to have an even shine without puddles. Pick up Orange on your 1 inch brush and lightly wash it into the lower sky area, fading the color as you move left. You will also want to bring the color down into the top of the hill area. As you continue to add color, add more water.

Next with a clean brush pick up Manganese Blue and wash it into the upper sky area. Paint in a touch of Thalo Blue to this area as well; be careful and use it lightly as this color can become quite intense. Along the very top of the sky add a wash of Ultramarine Blue. Blend the colors, and do not work too much of the blue into the orange as it will quickly become muddy. If an area becomes too dark, while it is still wet you can lift out color with a paper towel or near dry brush.

While the sky is still wet, pick up a mixture of Violet and Thio Violet, paint this lightly into the upper left sky area.

You will want to paint in the clouds while the sky is wet, use your angular brush with a mixture of Violet and Thio Violet. Load the point of the brush with more pigment. Lightly tap in uneven shapes to suggest the clouds. Look at the photograph for reference. When tapping in clouds close to the horizon use less pigment and paint them lighter.

HILLS

If the hill has begun to dry, re-wet it with a clean application of water; be sure to paint around the barn shapes. With your 1 inch synthetic brush pick up a touch of Indigo on one corner, use that side along the top edge of the hill. Clean your brush and apply a few light washes of Orange. Again, be careful when painting blue and orange together as they quickly become muddy.

BACKGROUND FOLIAGE

Use your foliage brush to pick up Yellow Ochre and Raw Sienna. Start on the right side of the painting and begin lightly tapping on the foliage, be sure to tap around the barn shapes. Also, tap on Hookers Green Deep into the background area. Be careful to not load the brush with too much water, or the background colors will melt together. Continue to paint over to the left side of the painting, varying the tone, value and shape of the foliage as you work along. Keep in mind soft colors recede, and bright colors push forward.

WATER

Pre-wet the water area using clean water and the 1 inch synthetic brush. Be aware of making the edge of the water uneven, as it is protrayed in the photograph and tracing. Start by painting a light wash of Orange into the water, think of reflecting the sky in the water. With a clean brush add Manganese Blue, Cobalt Blue, Ultramarine Blue, Violet and Thio Violet, mirror the sky. Along the left bank reflect the trees (which we will paint in a later step) into the water. Look at the photograph before starting, use Hookers Green Deep, a touch of Olive Green and a touch of Raw Sienna. As well as washing on the color for the tree reflections, you will want to tap some of the color on with your foliage brush to give a more realistic effect.

DISTANT BARNS AND SILOS

Use your angular brush to pick up Burnt Sienna with a touch of Indigo. Load the tip of the brush with more paint. Stroke on the sides of both barns and the silo first, make sure they are a bit darker under the eaves, and darker to the left on the silo. Next add a wash of Indigo and Cobalt Blue to all three roofs. If the roof areas have become too dark, you may want to mix in Chinese White to lighten the color a bit.

To set the barns into the landscape, you will need to come back in and tap some foliage around the barn area. Do not over detail this area or it will push forward visually.

GROUND AREAS

Paint in the middle ground with a wash of Raw Sienna and touches of Hookers Green Deep. start from the barn area and work forward along the edge of the bank and up into the left background area. In the background this is painted as a final application of color, in the foreground this is just a foundation for the foliage and bank to take shape from. You will also want to wash in the small bank to the right.

FOREGROUND FOLIAGE

Use the foliage brush to pick up Hookers Green Deep, while the foreground is still wet tap on the color. We will build this area in a series of layers, so at this time concentrate on laying in areas of paint to build from. With the foliage brush also apply touches of Burnt Sienna and combinations of Hooker Green Deep, Olive Green and Indigo to create richer tones.

TREE

Use the foliage brush to pick up Hookers Green Deep, touches of Thalo Green and Burnt Sienna. As you tap on the foliage move the brush in different directions so as not to repeat the same pattern. On the right side of the tree add some suggestions of Orange and English Red to reflect the warm light from the horizon. Be sure to keep the foliage light allowing the sky to show through in small patches.

ROCKS

Using an angular brush pick up Burnt Umber on the tip of your brush to paint in the rocks. After you have painted on the rocks, take the brush and flip it against your finger to speckle the ground area on the left bank.

BRANCHES

Using a liner pick up Burnt Umber to paint on the branches with. As you paint on the branches think of them as disappearing and reappearing from the foliage. Look at the photograph.

FINISHING TOUCHES

Use your liner to pull up some grass blades.

With the foliage brush tap in wildflowers. Use a mixture of Cobalt Blue and Chinese White for the blue flowers, and a mixture of Thio Violet and Chinese White on the rose colored flowers.

You may want to add touches of Thio Violet to the left edge of the bank.

Look at the photograph for reference.

BIRDS ON THE BUCKETS

WATERCOLOR PALETTE
Cadmium Red Light
Thalo Crimson
Grumbacher Red
Paynes Gray or Indigo
Thalo Green
Hookers Green Deep
Cadmium Yellow Medium
Burnt Umber
Burnt Sienna

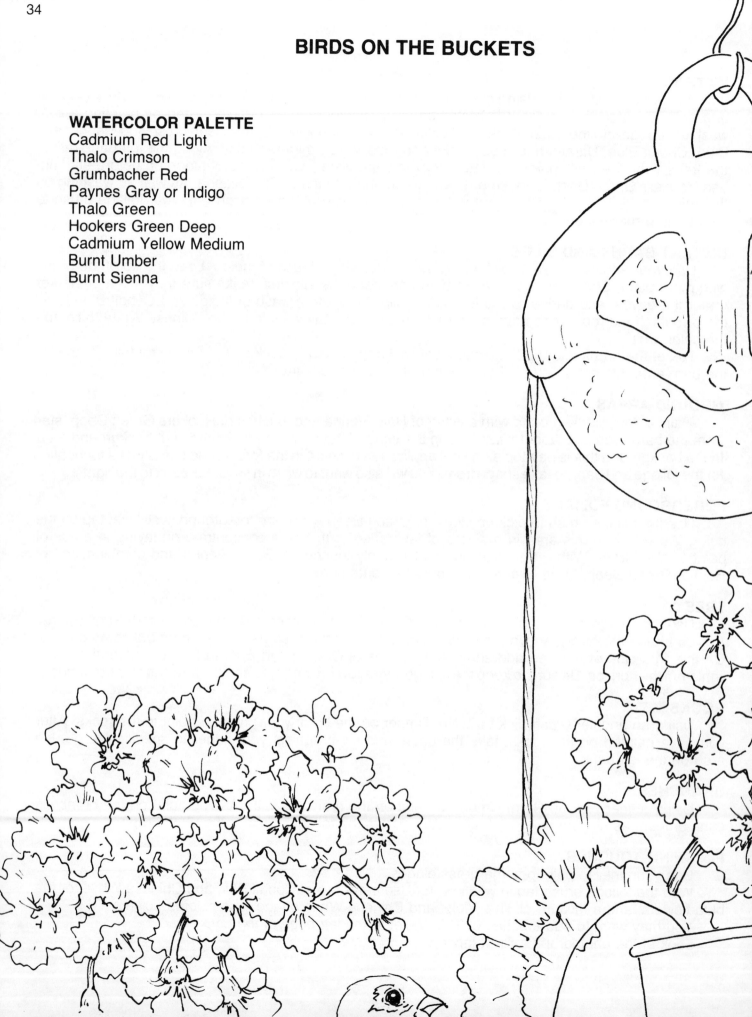

BRUSHES
1 or ¾ inch Synthetic Flat
Size ½ or ⅜ Angular Shader
Size 4 Round
Size 1 Liner

Paper 260 or 300 Cold Pressed

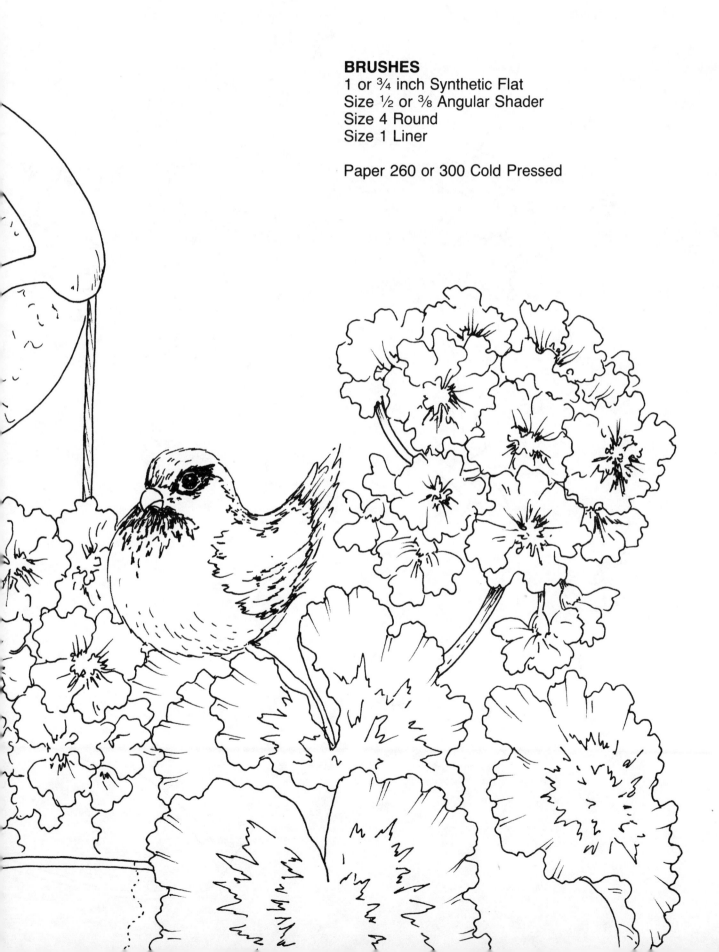

© 1992 SOReWB

On the P.B.S. Series, "The Gift of Painting" I used a portion of this painting as one of my lessons, I hope you will enjoy it.

BIRDS ON THE BUCKETS

Trace the pattern onto the watercolor paper with either Saral graphite transferring paper, or a graphite pencil. Be careful not to press hard when transferring the pattern as it is easy to dent the paper. If you do dent the paper, color will flow into the recess and it will show as a dark mark.

But, I would like to add that sketched pencil lines are often a part of traditional watercolor, it is all in what you prefer.

Be sure when transferring the pattern that the eye is drawn on carefully and round.

BIRDS ON THE BUCKETS

BIRD EYE AND BEAK

The eye is painted using Burnt Umber and Indigo. With your liner paint a circular line inside the rim of the pupil, be sure to leave a highlight of white paper near the top right. While the brush is still loaded with pigment, paint the top of the beak leaving a thin white line between the top and lower beak.

BODY

Keep in mind as you are painting the body of the bird, that we are creating a series of glazes. So build the color up in layers, and do not try to put it all down at once.

Next pick up your 3/8 angular brush sideloaded with Burnt Umber, test the color on another piece of paper to see how dark it is. Place the point of the brush underneath the chin area and in small tapping, pulling motions paint part of the way down the chest of the sparrow. Tap in a direction that will suggest the growth pattern of the feathers and look at the photograph.

Underneath the wing at the base of the body, apply Burnt Umber with a touch of Indigo, pull the color upward following the contour of the body. Leave the belly area cream colored.

Along the top of the head, apply Burnt Umber and Burnt Sienna. Look at the photograph for exact placement. Paint down and into the base of the neck, again pay attention to the direction of the feathers. Leave the area around the eye white, we will be painting this in a later step.

Paint down the back side of the body picking up a bit more Burnt Sienna. Very lightly work across the wing, leaving areas of white, and keep in mind the direction of the feathers.

Next dip just the point of the brush into Burnt Umber and come up to the area where the long feathers on the wing. Tap and pull into that area to create a shadow along the feather transition. Next turn the point of the brush loaded with Burnt Umber and a hint of Burnt Sienna towards the end of the tail feathers, pull in even strokes back up towards the body.

Let the body dry. Load the tip of the brush with Burnt Umber and Burnt Sienna, go back into the body and feathers to add glazes of color creating more texture and depth.

Paint in the area surrounding the eye using a #4 round, pick up a strong mixture of Burnt Umber to paint the mask. Make sure to leave the white area around the outside rim of the eye, look at the photograph.

PAIL

Pre-wet the pail, do not pre-wet or paint the rim, or the handle at this point. Use your angular brush sideloaded with Indigo. Start from the left side of the pail and pull downward. Paint the pail the darkest on the left, and lighten the color as you move around to the center and right. You will also want to add touches of Burnt Umber. Underneath the leaves you will want to shade with Indigo, Burnt Umber and a touch of Hookers Green Deep to lightly reflect the leaves. Look at the photograph.

FLOWERS

Using an angular brush pick up some Grumbacher Red, Thalo Crimson and Thio Violet, on the point. Check the color on another sheet of paper to make sure it is graduated along the brush. Also, this is a good time to check the amount of water on your brush, if there is too much gently blot your brush against a paper towel once or twice before beginning.

Start by painting the most forward geraniums in the bunch. You want these forward flowers to have strong vibrant shapes, then fill in with background petals. Place the point of the brush to the center of the flower, the entire surface of the brush against the paper. Slide and twist the brush around to create each petal. To deepen the center area add Thio Violet.

Next pick up some Cad. Yellow Medium with the liner and tap the centers of each flower, look at the photograph.

After the flowers have dried, pick up Hookers Green Deep and paint in the stems of the geraniums.

RIM AND HANDLE OF THE PAIL

With an angular brush pick up Indigo, and define the rim and handle of the pain. After the rim has dried, come back in and add the slight shadow underneath the lip.

LEAVES

Start with the farthest right leaf pre-wetting it with clean water. Pick up Hookers Green Deep on the point of the brush only, and use the point of the brush along the outer edge of the leaf. You will also want to add a hint of Indigo along the outside edge as well. From the outside of the leaf draw the brush inward, following the contour to the center with thin washes of color. While the leaf is still wet, load your brush with Hookers Green Deep and Indigo, tap on the middle ring of color. Allow the color to diffuse a bit. You will also want to add a few very slight suggestions of Grumbacher Red. Use the same technique on the other leaves. Do not work one leaf wet, next to another or the colors may bleed together.

ROPE

The rope on the scale was painted with a liner using Yellow Ochre. Come back next to the turn wheel and apply Burnt Umber and Burnt Sienna.

METAL HOOK

Paint the hook using Indigo, use your liner.

METAL CASE

The metal case has a mottled appearance. Pre-wet the entire metal section. While the area has a shine apply, more Indigo towards the left and add more water to dilute to the right. Pat a little more Indigo in small uneven dabs to give a more realistic appearance. Allow this to dry prior to painting the wooden turn wheel. Once the metal section is dry take a liner and make a diluted Indigo circle to show the screw turning.

WOODEN WHEEL

Pre-wet with water and then come back and pat on variations of Burnt Sienna, Burnt Umber and hint of Indigo, start light. Continue to come back and tap uneven patterns using deeper values as you continue. The uneven appearance will make this more realistic.

While visiting a good friend Charleen whose home is high in the Rockies, I started the scale and buckets that were hanging in her beautiful mountain home. I did a sketch of the scale and decided a nice touch would be to add the birds. It's fun to take objects you or your friends have and paint them.

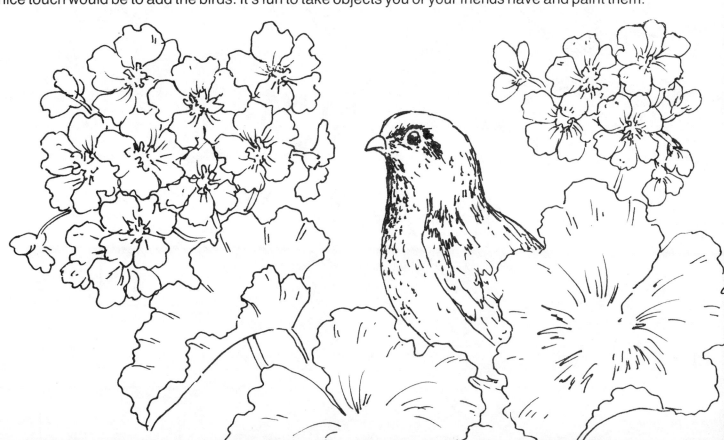

SUNFLOWERS

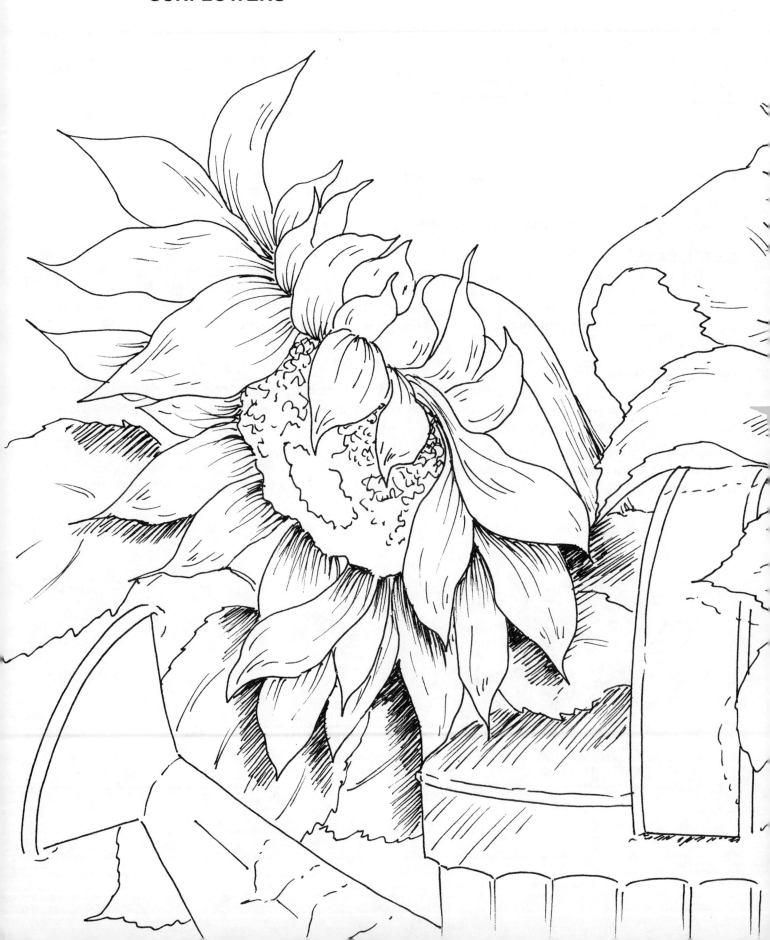

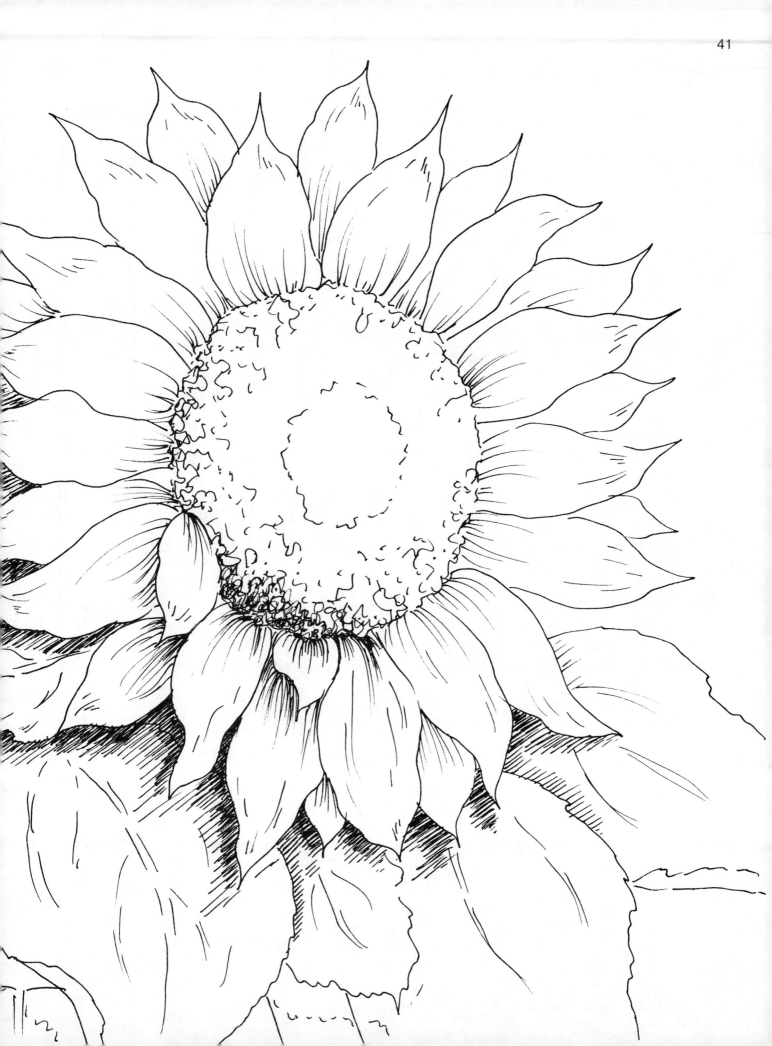

On the P.B.S. Series, "The Gift of Painting" I used a portion of this painting as one of my lessons, I hope you will enjoy it.

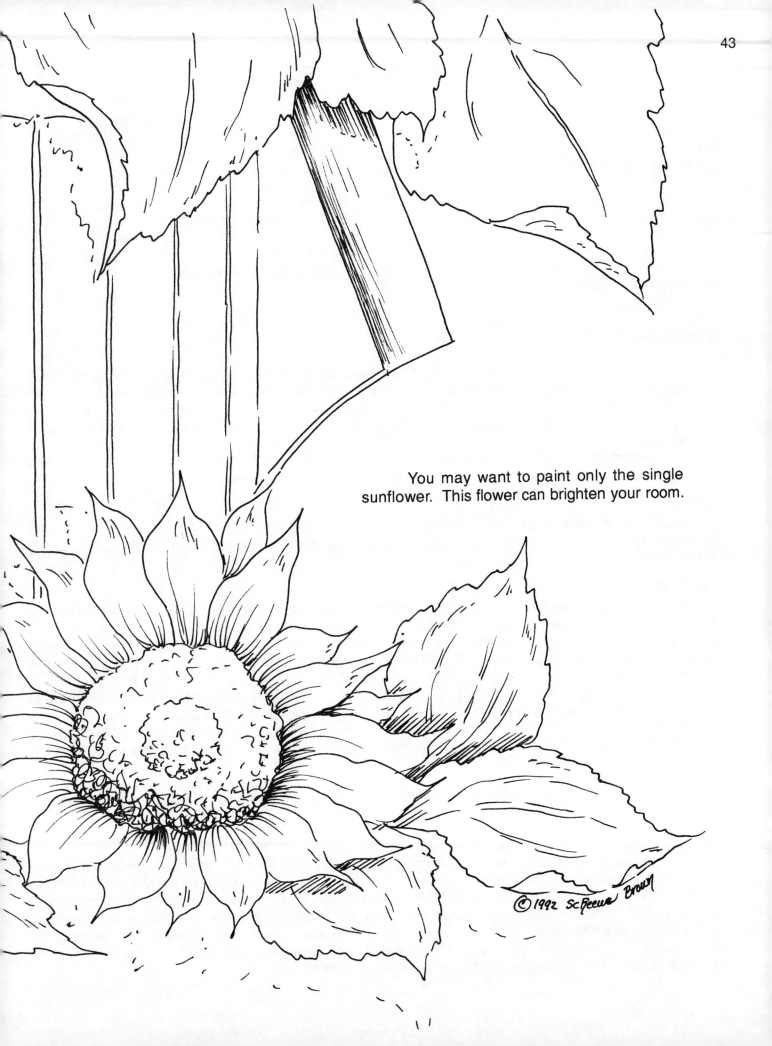

You may want to paint only the single sunflower. This flower can brighten your room.

© 1992 Sc Reewe Brown

SUNFLOWERS

WATERCOLOR PALETTE
Cadmium Yellow Pale
Cadmium Yellow Medium
Cadmium Orange
Raw Sienna
Burnt Sienna
Burnt Umber
Thalo Green
Hookers Green Deep
Sap Green
Indigo
English Red

BRUSHES
¾ or 1 inch Synthetic Flat
Size 1 Liner
Size ½ Angular
Size ½ Foliage Brush

Test Paper
260 Winsor Newton Coldpress

Trace the pattern onto the watercolor paper with either Saral graphite transferring paper or a graphite pencil. Be careful not to press hard when transferring the pattern as it is easy to dent the paper. If you do dent the paper, color will flow into the recess and it will show as a dark mark.

But, I would like to add that sketched pencil lines are often a part of traditional watercolor, it is all in what you prefer.

This entire painting involves a series of glazes, one atop another, so have patience in building up your colors. Start light, working into the richer tones with subsequent layers.

PETALS

Using your angular brush, pick up Cad. Yellow Pale on the tip. Paint each petal keeping the point to the outside edge. This is the first layer of color to be applied to the petals. Allow the petals to dry at this point.

CENTER

With the foliage brush, tap up and down on the palette to pick up English Red and Burnt Sienna. Try to graduate it so there is more pigment on the point of the brush. Check your color on a test sheet of paper. You will also want to make sure that you do not have too much water on your brush. If you do have too much water on the brush you will not be able to achive a textured appearance in the center area, the color and texture will diffuse and bleed together.

Start with the point of the brush facing outward, tap on the outside ring of the center. Next tap in the center circle. Be sure to leave small flecks of white paper showing through.

Slightly shade the outer left edge of the center with a deepened application of Burnt Sienna.

After the center area has dried you will want to come back in and add the next layer of color. Using your foliage brush, pick up a "touch" of Cad. Yellow Medium and apply a suggestion into the upper center area. Look at the photograph to get an idea of shading, color placement and tones.

Remember, watercolors always dry lighter, so feel free to come back in and darken with added layers of color.

PETALS

Use your angular brush to pick up a very light touch of Burnt Sienna and Raw Sienna on the point of the brush. Throughout working on the petals you will want to use variations of these two colors. On another strip of paper test to make sure that the point of the brush is darkest, with the color graduating to almost nothing at the other end. Place the point of the brush on the petal against the outside edge of the center, keep the entire surface on the petal against the outside edge of the center, keeping the entire surface of the brush in contact with the paper. You may want to rotate the paper as you work on each petal. Look at the photograph for shading reference.

LEAVES AND STEMS

Begin with a first glazing of Hookers Green Deep and touches of Cad. Yellow Medium on your angular brush. Do not worry about detailing at this time. This first wash is somewhat light, we will be adding richer tones in layers over the top of this.

On the curled back portion of the leaf, make it slightly darker behind the curl, and lighter on the front side. You may want to pre-wet each leaf as you work if you feel the need for more painting time. Or, if you work faster there may not be a need for pre-wetting. Let this step dry.

SHADOWS

While the leaves are drying, pre-wet the shadow area underneath the bottom leaves and petals. Look at the photograph for reference before starting. Begin using Indigo; Cad. Yellow Medium and few very light touches of Hookers Green Deep on the lower shadows. On the upper shadows, behind the petals and leaves, use a light wash of Indigo and Hookers Green Deep.

LEAVES

Work back into the leaves with glazes one at a time, creating darker tones with Hookers Green Deep, touches of Sap Green, Cad. Yellow Medium and Yellow Ochre. The last three colors are very light additions to a few of the leaves. To create the veins we will use a combination of techniques. Some veins are created by allowing a thin line of the underlying color to show through, others by overlapping color, and some by shading. Again, look at the photograph for reference.

WATERCAN

Pre-wet with clean water one section at a time as you paint the watering can using an angular brush. While the paper has a shine apply Indigo using the angular brush picking up more pigment on the point of the brush. Refer to the photo for additional help with color placement. Deepen the color under the rim and towards the side of each section.

Pre-wet the handle applying clean water, come back while the handle has a shine and apply Indigo on the point of the brush and apply the point of the brush towards the left side and across to create a shadow.

Spout – Pre-wet the entire spout. Using Indigo apply more color to the top and lower edge. While the spout is still wet apply a darker area to create the appearance of an indent in the spout. Come back and deepen slightly an area to create a shadow.

Sprinkler top is done by first pre-wetting the large section but not the rim. Apply a thin wash of Burnt Umber and Burnt Sienna. Come back and add Indigo for the shadow area.

Once the paper has completely dried come back and add some tints of very diluted yellow, glaze on the watercan to give the appearance of reflections. Glaze on a tint of diluted browns to reflect the sprinkler head towards the left side. Tints of very diluted greens are used in the leaf shadows and tints of very diluted yellow are used on the top handle.

Finish the top rim of the sprinkler section using a lighter section with a mixture of diluted Burnt Umber, Burnt Sienna and hint of Indigo at the lower section to shadow. Wait until dry and paint a fine line using Indigo almost fading out at the top.

There is a farm near us that sells fresh fruit, vegetables and grow flowers you can go out in the field and pick. On a beautiful Fall day my daughter Camille and I went out to cut a beautiful sunflower bouquet. We selected medium and small flowers. The full size were so very large we decided the smaller variety would work better for our bouquet. I've had the old watering can for sometime and the sunflowers seemed perfect. It's so much fun painting from my own fresh bouquet.

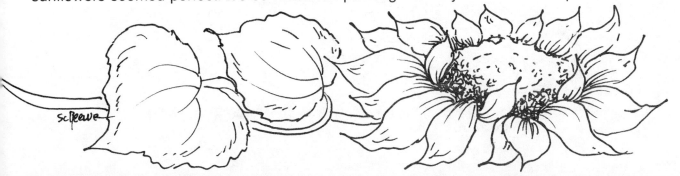

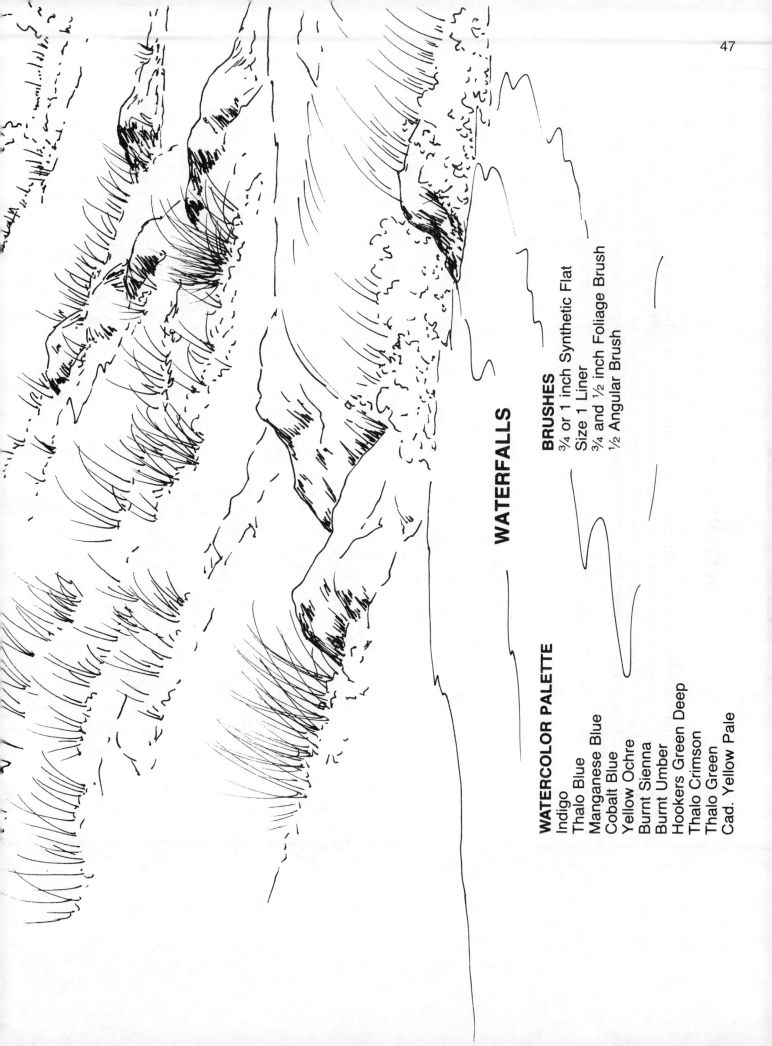

WATERFALLS

BRUSHES
¾ or 1 inch Synthetic Flat
Size 1 Liner
¾ and ½ inch Foliage Brush
½ Angular Brush

WATERCOLOR PALETTE
Indigo
Thalo Blue
Manganese Blue
Cobalt Blue
Yellow Ochre
Burnt Sienna
Burnt Umber
Hookers Green Deep
Thalo Crimson
Thalo Green
Cad. Yellow Pale

48

WATERFALLS

Trace the pattern onto the watercolor paper with either Saral graphite transferring paper or a graphite pencil. Be careful not to press hard when transferring the pattern as it is easy to dent the paper. If you do dent the paper, color will flow into the recess and it will show as a dark mark.

But, I would like to add that sketched pencil lines are often a part of traditional watercolor, it is all in what you prefer.

It is important to read through all of the instructions before beginning this painting.

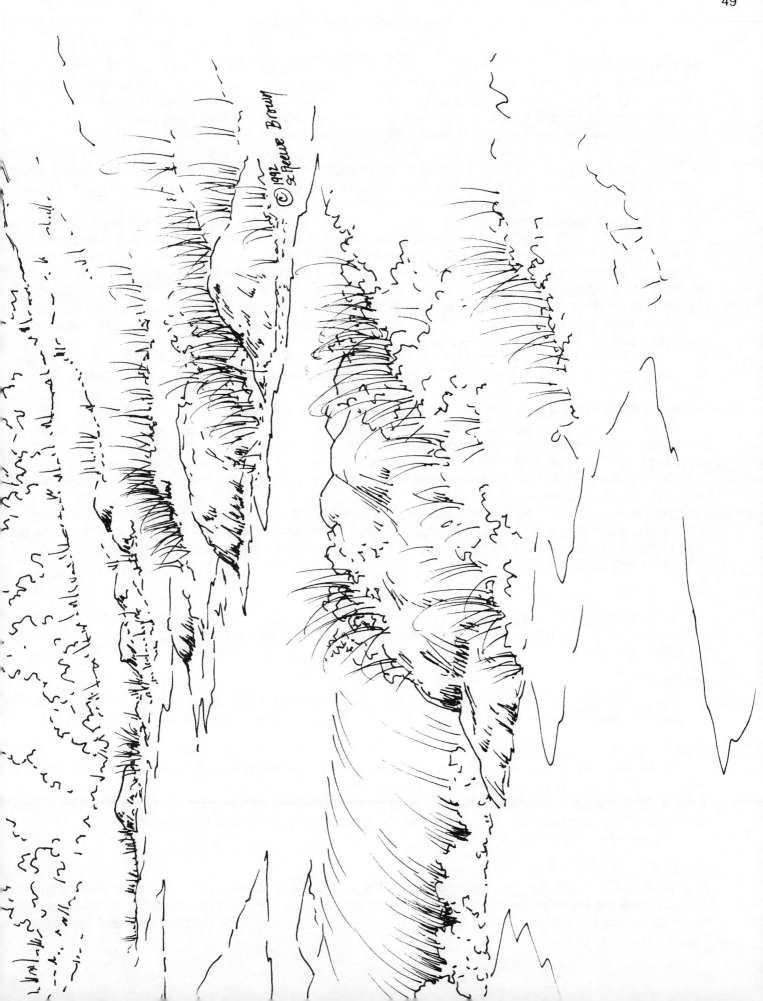

WATERFALLS

SKY AREA, TREES AND FOLIAGE

Pre-wet the sky area down to the base of the tree line. You want this area to be good and wet, with an even shine, but not to the point of puddling. The tendency is to not wash enough water into the paper; in this project a lack of water will result in not enough working time. Keep in mind you will need to add the first layer of distant trees into the sky area while it is still wet.

Pick up Cad. Yellow Pale and wash this color unevenly into the sky area on the lower 1/2 or 1/3 of the painting; this color will later reflect through the trees. To the top portion of the painting apply Cobalt Blue and a touch of Indigo. You may need to add some water to dilute the color bit. You will also want to add a hint of Manganese Blue into the upper sky area.

Add the diffused trees along the horizon, working up into the sky. Use the foliage brush with variations of Indigo, Thalo Blue and Cobalt Blue. This first layer is slightly diffused and will dry lighter, we will deepen the tones later with repeated applications of paint. Think about creating uneven shapes as you are applying the trees. Do not create a hedge, this will make the area too heavy for the painting. Instead, be conscious of leaving sky area to reflect through the foliage, this will give the illusion of space and depth. It is always better to start light, then you can darken by adding more paint.

Add richer and darker tones into the tree area, pick up Indigo towards the tip of the brush, plus pick up Burnt Umber and Burnt Sienna; use less water and more paint.

You will need to work fast through this next step, for if the paper begins to dry, you can no longer work into the area with this technique. With the chisel cut end of the synthetic brush, scrape against the paper to create tree trunks and branches. This will push the paint aside revealing lighter paper. When scraping into the paper, it takes a bit of pressure, be careful not to tear the paper.

You do not need to scrape in all of the trees and branches, we will be painting them in with a liner later. If for some reason the paper has begun to dry and you are unable to scrape in any trunks or branches, do not worry, you can always paint them with a bit of Chinese White.

Next you will want to tap on foreground foliage along the base of the tree line with darker variations of Indigo, Burnt Sienna and Burnt Umber.

At the base of the tree line you will want to use the 3/4 inch synthetic brush with clean water to diffuse the edge and give shape to the background. If the water backflows a bit into the tree area do not worry, it will add texture to the foliage. If it starts to create a large bloom you may want to dab it up with a dry paper towel.

With a 3/4 inch synthetic flat you will want to apply variations of Indigo, Burnt Sienna and a hint of Raw Sienna to create the ground contours of the middle and foreground area. Look at the photograph for reference.

ROCKS

Next you will want to paint on the rocks using a 3/4 inch synthetic brush. Pick up Indigo and a bit of Burnt Sienna on the corner of the brush; use the pigment loaded corner of the brush along the top of each rock. Also, it is important not to paint the rock just to the left, right and center of the waterfall, it will be painted in a later step.

Some hints when painting rocks; do not paint all of the rocks the same tone, shape and color, be sure to vary them. Also, be aware of painting rocks in a manner that will make them appear to be from a similar area. And finally, you may want to dab out some of the color on a few rocks to create texture and slight variation in their appearance. Look at the photograph for reference.

If you need to rest, this is a good stopping point.

GRASS

With the 3/4 inch foliage brush, pick up Indigo, Hookers Green Deep and a small bit of Raw Sienna. Use the brush in combinations of tapping and flipping the hairs to create the grass. You may need to re-wet the middle ground a touch to achieve the combination of diffused grass blades and clean hard edge grass.

WILD ROSES
pages 86, 87, 88

GARDEN GATE
pages 18, 19, 20, 21

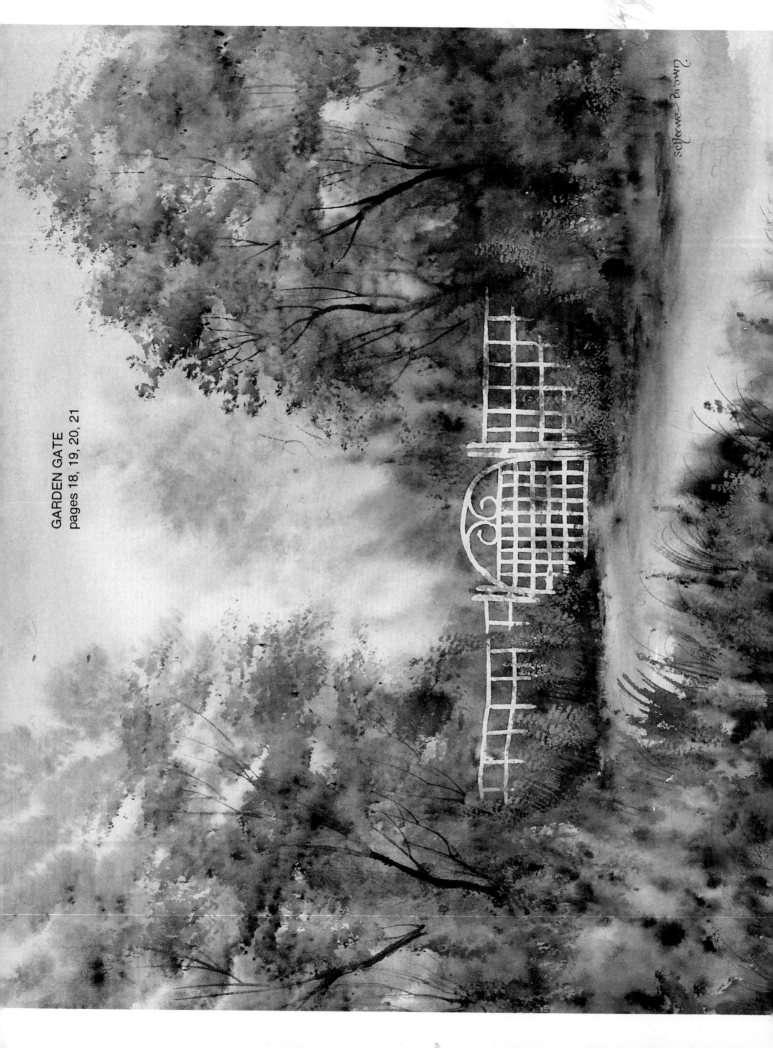

HAZY DAWN
pages 78, 79, 80, 81

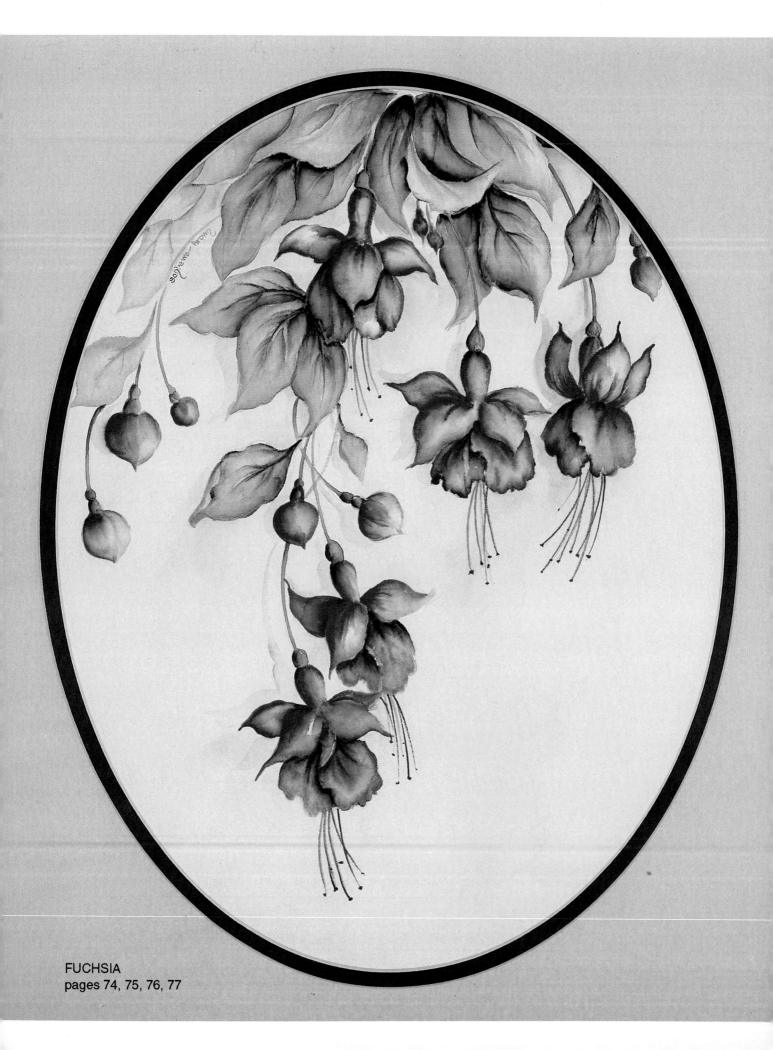

FUCHSIA
pages 74, 75, 76, 77

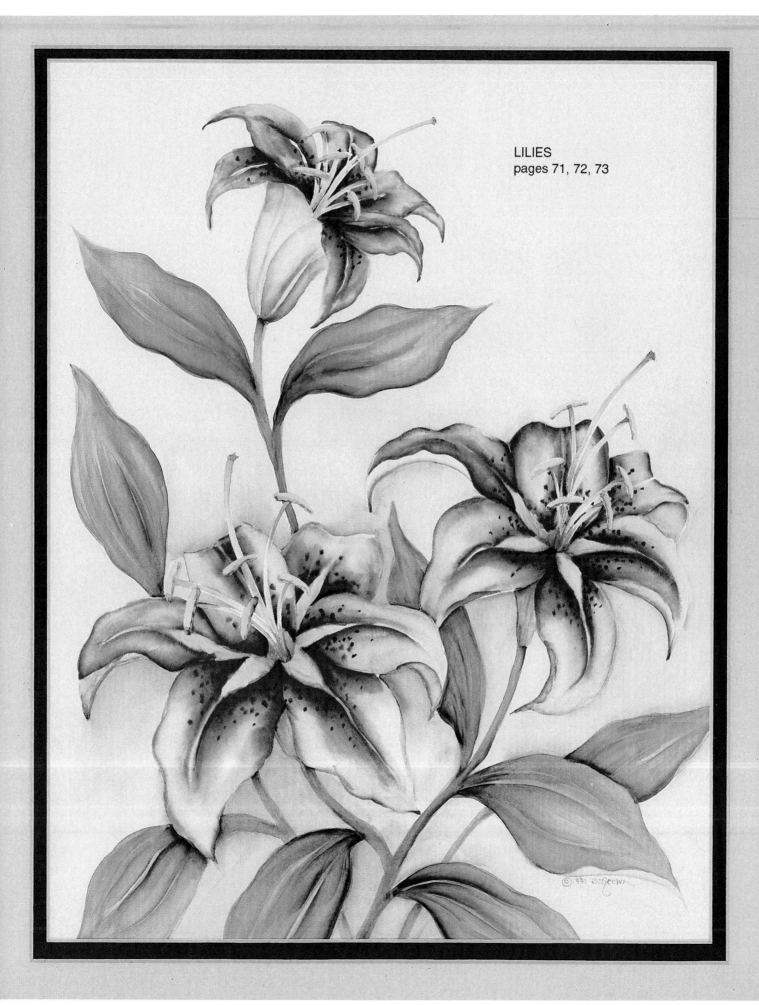

LILIES
pages 71, 72, 73

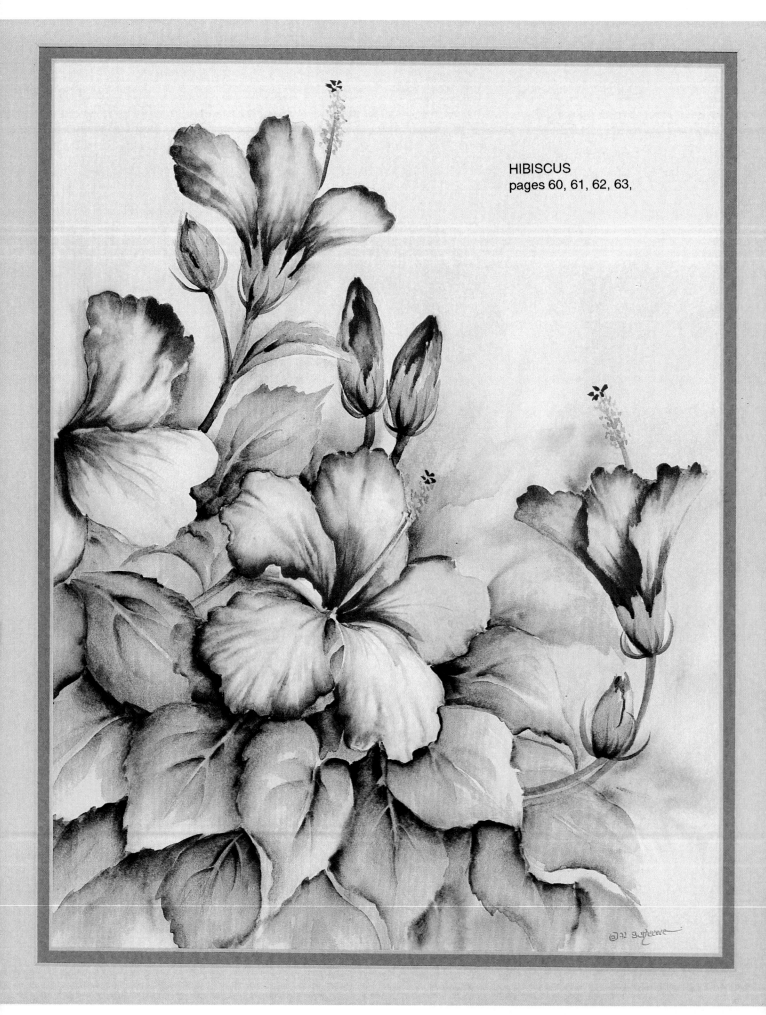

HIBISCUS
pages 60, 61, 62, 63,

WATERFALL AND WATER

Use your 3/4 inch synthetic brush to pick up a diluted hint of Indigo, Mangnese Blue and Cobalt Blue. Tap your brush against a test sheet of paper to split apart the brush hairs, tap a broken edge across the top of the foam to start the waterfall from. You will want to split the hairs when you stroke on the waterfall as well. At the base of the waterfall, place your brush and lightly pull up and to the right in a slight arching motion following the roll of the waterfall. Be sure to leave the white of the paper where the foam is along the base of the waterfall.

Wet the line along the bottom edge of the foam from the falls, apply a shadow of Indigo and slight touch of Burnt Sienna.

After the previous step dries you will want to add rocks to the left, right and center of the falls. Refer to the section on rocks for instructions.

When the rocks have dried, you will want to use your angular brush to carry a light diluted wash of blue upward along the bottom edge of the foam, to give it dimension. Along the top edge of the foam use the very point of your brush to create a few darker areas using Indigo. Look at the photograph for reference.

Pre-wet the water area above the falls leaving the crest of the fall area dry and white. Bring a bit of Cad. Yellow Pale from the sky into the water also adding Indigo and touches of Burnt Sienna, plus reflections from the rocks.

On the lower water area use Indigo with touches of Burnt Sienna.

FINISHING DETAILS

You will want to use your liner to add some distinct grass blades to the ground area.

Tap in darker values to the foliage, rocks or grass if they have lightened too much. Or soften and edge that is too harsh with clean water.

You will want to use your liner to add branches and trunks to the tree area, use variations of Indigo and Burnt Umber.

In the water area, if your foam shrank more than you would like, or you would like to fluff up the foam a bit more; you can add touches of Chinese White tinged with Indigo on the tip of a liner.

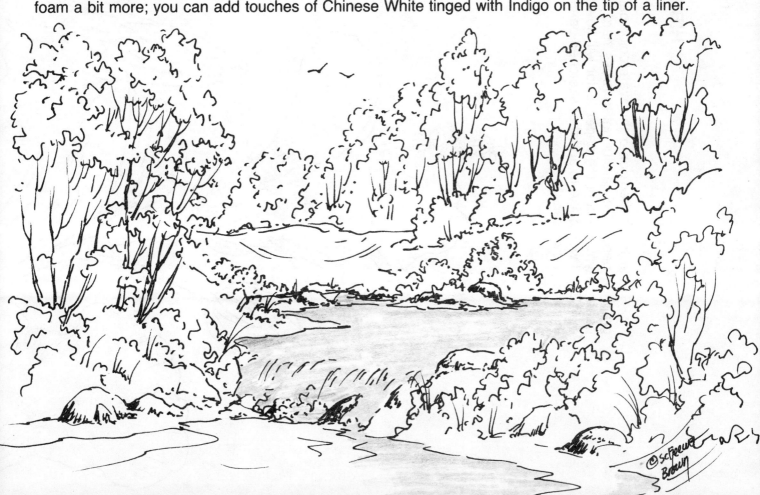

60

HIBISCUS

Trace the pattern onto the watercolor paper with either Saral graphite transferring paper or a graphite pencil. Be careful not to press hard when transferring the pattern as it is easy to dent the paper. If you do dent the paper, color will flow into the recess and it will show as a dark mark.

But, I would like to add that sketched pencil lines are often a part of traditional watercolor, it is all in what you prefer.

WATERCOLOR PALETTE
Thalo Crimson
Cad. Red Light
Thio Violet
Cad. Yellow Medium
Magnesium Green
Hookers Green Deep

BRUSHES
¾ or 1 inch Synthetic Flat
Size 1 Liner
½ inch Synthetic Angular

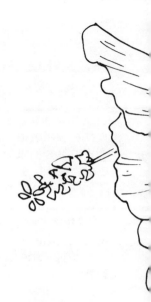
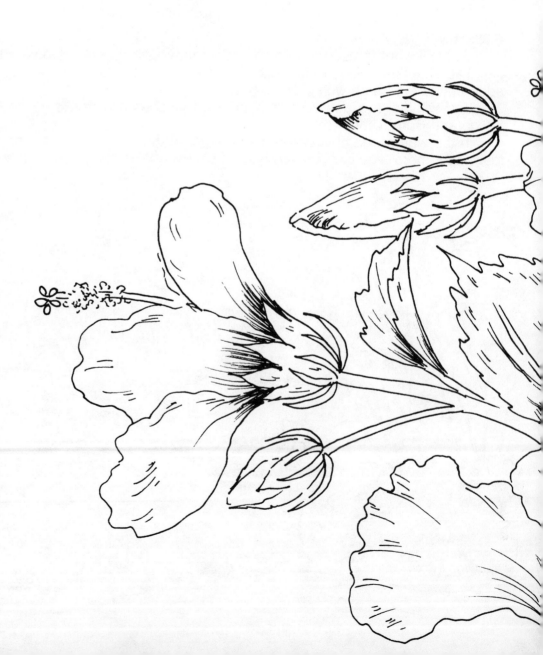

HIBISCUS

BACKGROUND

Begin with pre-wetting the area around the flowers and leaves, using a 1 inch synthetic brush and clean water. Use Thalo Crimson, Thio Violet, small touches of Hookers Green Deep and Indigo. Work your way around the outside edge of the leaves and flowers. Paint the stronger color near the foliage and blend the color outward, unevenly to create the background. Be sure to allow the background to dry before continuing on.

FLOWERS

Pre-wet with clean water, one flower petal at a time as you work along. Use Thalo Crimson and a hint of Thio Violet on the tip of your angular brush.

Begin working with the center flower, starting with the right petal. On all three of these top petals you will want to make the center darker, pulling the color outward, contouring the shape of the petal. Be sure to keep paint on the point of the brush, use the entire surface of the brush on the paper and keep the point to the outside edge. You will also want to test your color on a separate sheet of paper before applying it to the paper.

Next, alternate to the lower left petal. If you look at the photograph you can see the petal's outer edge is darker. Because it is a forward petal, you do not need to deepen the center as much. Pre-wet the petal, then begin with Thalo Crimson and a "touch" of Thio Violet on the tip of your angular brush. Keep the point facing to the outside edge. To create the ruffled effect on the outer edge of the petal, you need to use a combination of a stroke, then a short pull in towards the center. Use the flat edge of the brush and give attention to the contour of the petal. Pull a few strokes of color out from the center as well.

Now let the two petals just painted dry and move to another flower.

Move to the upper left hibiscus and pre-wet the upper left petal. Now you have the idea of the process involved in painting the petals. Be sure to rotate the petals you are painting; and never paint two petals wet, side by side, or they will bleed into each other. Look at the photograph.

On the center flower, the upper left petal has a turned back ruffle on its lower left side. When you pre-wet the petal, do not pre-wet the turned back edge. Look at the photograph for reference. You want to paint the area just behind that edge darker. Before you paint the turned back edge of the petal, the petal must be completely dry or the paint will bleed together and there will be no distinct edge.

An important note on the center flower's top petal— be sure to leave a white unpainted space for the stamen.

BUDS

On the buds you can apply color direct without pre-wetting. Start with the left center bud, load the tip of your angular brush with Thalo Crimson and a touch of Thio Violet. Keep the point of the brush to the outside edge, brush lying flat, and begin with the left petal. After it is painted, allow time for it to soak into the paper a bit before applying the right petal. Pick up more Thalo Crimson and Thio Violet on the point of the brush, place the brush inside along the ruffle and wiggle the brush downward. Darken the area just behind the stem calyx. Look at the photograph.

If you find your bud has become too dark, before the color dries, you can lift some color back out with a dry brush or paper towel.

STAMENS

After you have painted on all of the buds and flowers, you will want to add the stamens. With a liner, pick up some Thalo Crimson lightly diluted and paint the stamen on each of the three hibiscus. On the center hibiscus you may need to darken the left edge slightly so it will show up. Then with your liner, pick up some Cad. Yellow Medium and gently tap on the spray at the top of each stamen. At the very end of each stamen there is a five pointed flower (star shape); paint it on with Thio Violet. Look at the photograph.

LEAVES

The leaves involve a series of glazing applications. Pick up Hookers Green Deep on the side of your 3/4 inch synthetic brush. You will use this to paint on the first layer of color. Do not worry about detailing the leaves at this point, we will be doing that in later steps. Before painting the first layer of

color, look at the photograph; do not be concerned with the interior shading, but focus on the overall shape, the shadows and which leaves are forward and which are behind. Also, be careful to not paint any upturned edges on the leaves at this point. You will also want to paint on the stems and calyx with Hookers Green Deep; but, do not paint on the small petals between the stem and calyx at this time.

After the leaves have dried, you will want to glaze over them to create veins, shadows and richer tones; plus paint the turn back edges. You will want to use combinations of Hookers Green Deep, Sap Green and touches of Magnesium Green. The veins are created by allowing a thin line of underlying lighter color to show through, others by overlapping color, and some by shading. Look at the photograph to give yourself a clearer visual image of what you are trying to achieve. Test your color often on another sheet of paper.

After the stem and calyx have dried, you will want to paint the leaves at the base of the stem using Hookers Green Deep and a touch of Sap Green. Continue to work color over color until you achieve the tone you are looking for.

To paint lavender Hibiscus use Violet and Thio Violet. Follow much the same instructions. Try a little Sap Green in the leaves for variation.

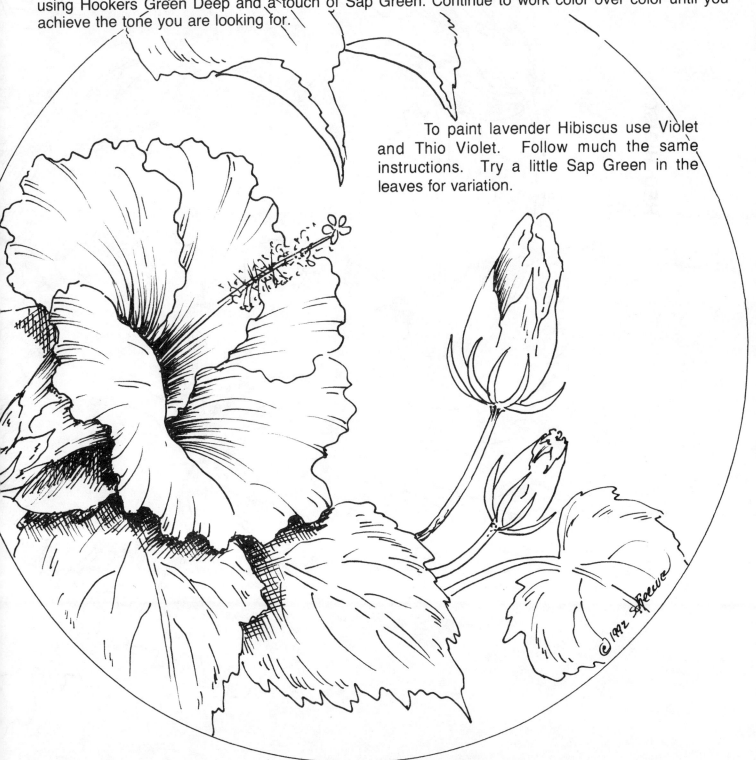

RED HIBISCUS

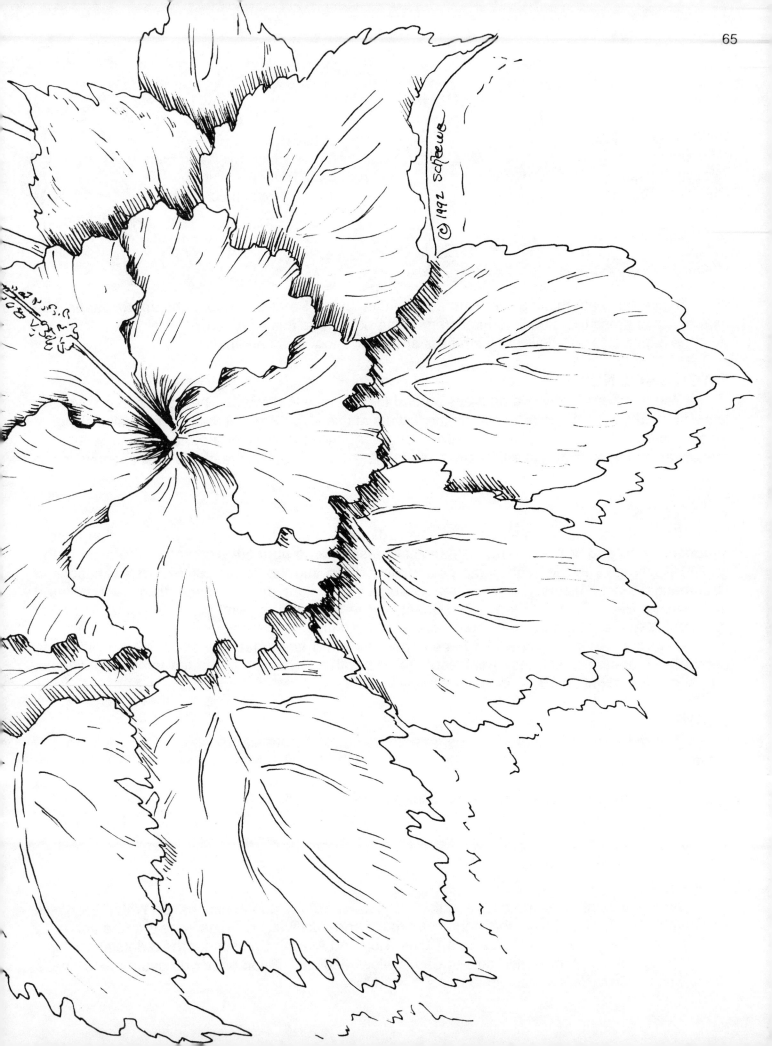

© 1992 Scheewe

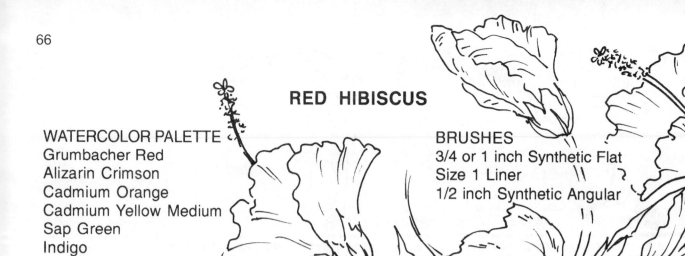

RED HIBISCUS

WATERCOLOR PALETTE
Grumbacher Red
Alizarin Crimson
Cadmium Orange
Cadmium Yellow Medium
Sap Green
Indigo
Hookers Green Deep

BRUSHES
3/4 or 1 inch Synthetic Flat
Size 1 Liner
1/2 inch Synthetic Angular

Trace the pattern onto the watercolor paper using Saral graphite transferring paper. Be careful not to press too hard when transferring the pattern as it is easy to dent the paper. If you do dent the paper, color will flow into the recess and it will show as a dark mark.

BACKGROUND

Begin with pre-wetting large areas around the leaves and flowers. The water can go over the leaves but be careful not to get water on the flowers at this step. Pre-wet the 1 inch brush picking up mostly Indigo and a hint of of Hookers Green Deep. Apply a hint of color around the outside edge of the leaves and flowers. Paint a little stronger value next to the leaves creating a cast shadow on the lower section.

FLOWERS

Pre-wet with clean water, one flower at a time as you work along. Brush direction is very important. Apply color using a 1/2 inch angular brush picking up more pigment on the point of the brush. Apply color to the edge of the petal pulling down into the flower center. Use variations of Grumbacher Red, Alizarin Crimson and Orange. The light pink is made using very diluted Grumbacher Red. To create the ruffled effect on the edge of the petal be sure to vary the color mixtures. While each petal is wet apply more Alizarin Crimson to the center.

Turn the paper as you work to keep your hand in a comfortable position. Don't paint one petal beside another petal, they will bleed into each other. Refer to the photo for additional color reference. Start light and deepen the color as you work.

BUDS

The red area is small on the buds, refer to the photo before starting to paint as you'll want to leave green showing. You can apply red tones to the buds without first pre-wetting. Pick up more pigment on the point of the brush using both Alizarin Crimson and Grumbacher Red. Be sure to let the red flower area dry completely before applying green values.

Use an angular brush to paint the lower section of the bud using Sap Green and a hint of Indigo. With the liner pull up a darker value green, the small thin sections.

STAMENS

After you paint on all the buds and flowers you will want to add the stamens. With a liner, pick up Grumbacher Red and paint the stem, come back and add Alizarin Crimson next to the center to deepen the value. Use a mixture of Grumbacher Red and Alizarin Crimson for the 5 dots at the top.

Using the liner tap on little dots of Cad. Yellow Medium. If you need you could mix Chinese White with the Cad. Yellow Medium to make them appear.

LEAVES

The leaves involve a series of glazing applications. Pre-wet the entire leaf with clean water. Start using a very diluted layer of Sap Green, don't worry about detailing the leaves at this step. Refer to the photo for help with color placement.

The center vein remains the light value as you add darker values to each side of the vein, pull out to the side to make side veins.

Slowly deepen the values using thin washes of Sap Green, Hookers Green Deep and Indigo.

FINISHING

You may find that you want to deepen the colors once they have dried. With a clean damp brush apply more color or pigment. Be careful not to pick up too much water on the brush as you apply more color, as you could create a backwash.

One of our very favorite places to vacation is in Hawaii. We have had the pleasure of meeting wonderful friends and teaching the Hibiscus during one of our many visits. I always prefer working from flowers and plants rather than photos of them.

The Hibiscus come in so many lovely colors and varieties it's hard to pick a favorite.

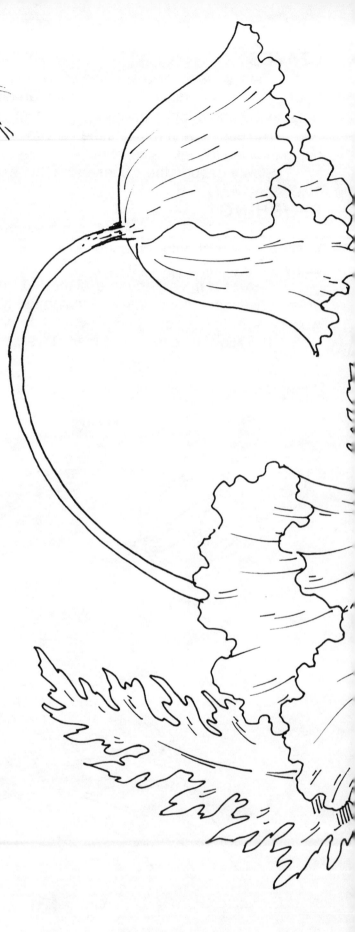

ORIENTAL FAVORITES

WATERCOLOR PALETTE
Cadmium Orange
Grumbacher Red
Thalo Crimson
Cobalt Blue
Indigo
Raw Sienna
Magnesium Green
Hookers Green Deep

BRUSHES
¾ or 1 inch Synthetic Flat
Size 1 Liner
½ inch Synthetic Angular

140 or 300 lb. Cold Pressed Paper
Test Paper

Trace the pattern onto the watercolor paper with either Saral graphite transferring paper or a graphite pencil. Be careful not to press hard when transferring the pattern as it is easy to dent the paper. If you do dent the paper, color will flow into the recess and it will show as a dark mark. But, I would like to add that sketched pencil lines are often a part of traditional watercolor, it is all in what you prefer.

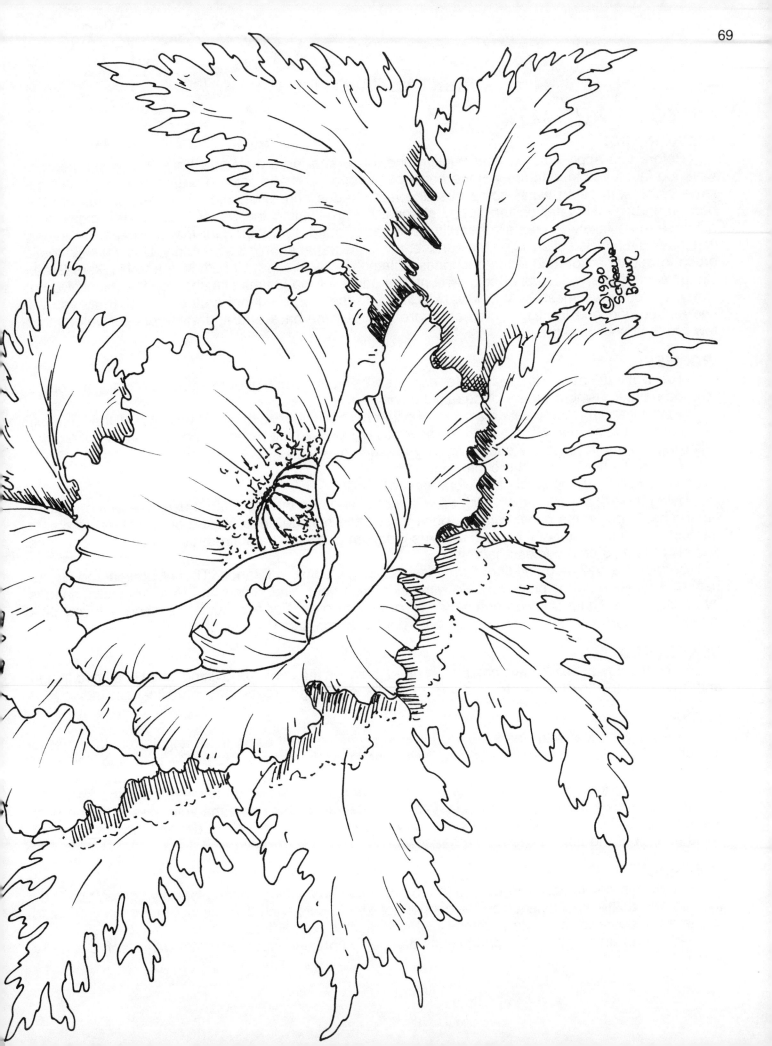

ORIENTAL FAVORITES

BACKGROUND

Before you apply color to your background, pre-wet a large area at a time. You would need to work too fast if you tried to pre-wet the entire background and add color in one step. Pre-wet using a large brush with clean water going over the leaf shapes and extending the water far out into the background. Avoid water on the poppy shapes. By pre-wetting the paper it allows the pigment to disperse more fluidly to create a beautiful soft background. It is important that the paper be evenly wet, having a consistant shine on the surface; rewet the paper should it start to dry. Use a 3/4 synthetic brush to apply background tones in shades of Indigo, Raw Sienna, Cobalt Blue and Hookers Green Deep. Work these variations of color around the edges of the leaves sketched on the paper. Do not worry, the color will most likely flow back a little into the leaf, it will not create a problem as you will see as you continue to paint. To create more depth, come back and add some deeper values to a few areas in your background.

POPPIES

Pre-wet each petal with clean water using a 1/2 angular brush prior to applying paint. The poppies can be painted using a variety of beautiful colors.

Start by testing your paint on a scrap of paper to check your color. Don't try to get all the variations of color on at once, you want to glaze on several layers. Build the colors by applying layers of pigment allowing the first layer to dry prior to adding another layer.

Be careful not to paint the center pod.

Start with the back petals and work forward.

Using the 1/2 angular brush, pick up a hint of Orange on the tip of the brush. The entire angular brush should be on the paper with the point toward the outside edge, sliding on the chisel to create the folds. Turn the point of the brush towards the stem, still with the entire brush touching the surface and slide back to create folds again.

Deepen the values by adding diluted layers using Cadmium Orange, Thalo Crimson and Grumbacher Red. Refer to the photo for help with color placement. You may wish to use more pink shades by adding more Thalo Crimson and very little orange or reds. For a beautiful variation, a lovely pink lavender poppy could be painted using only Thalo Crimson and Thio Violet.

CENTER POD

Once the flower petals have completely dried, paint on the center pod using a hint of diluted Indigo and Raw Sienna. Allow the area to dry completely prior to adding the dark lines with a liner and Indigo.

LEAVES

Pre-wet each leaf with clean water prior to applying pigment using a 1/2 angular brush. Refer to the photo for help with color placement. Use variations of Hookers Green Deep, Indigo and Raw Sienna with a few hints of Cobalt Blue and Magnesium Green. While the entire surface of the angular brush should be touching the paper, the point of the brush should first go to the edge of the leaf, then turn the point toward the center of the leaves to create veins. Don't take the vein lines to the edge of the leaves, let them fade. Come back and add glazes of darker values to deepen the area, accent veins and, near the poppies, to create shadows.

FINISHING

It's always helpful to come back and look at a painting. Since watercolors dry lighter, you may want to add a little additional color. Be careful not to add color with a really wet brush, as you could create a backwash bloom. Use a damp brush with a litttle pigment.

Should an area appear too dark, lightly dampen with clean water and blot with a soft clean dry paper towel.

LILIES

BACKGROUND

Begin with pre-wetting the entire background using a 1 inch brush with clean water, with the exception of the lilies. Start at the top of your paper and apply a mixture of diluted Hookers Green Deep and Indigo.

A hint of Thalo Crimson is also nice in the background. Try this effect on a test paper to see what you prefer. As you paint on the background the paper may begin drying, re-wet the paper as you paint along. Remember it is always easier to start light and apply deeper color slowly.

FLOWERS

Pre-wet with clean water, one petal at a time, on the large open flower using the angular brush. Make a very long thin triangle shape in the center of the pre-wet petal using Cadmium Yellow Pale and then a hint of Hookers Green Deep towards the center. Add a hint of Hookers Green Deep and Indigo in the very center.

Refer to the photo for help with color placement. The inside of the flowers have beautiful strong colors while the outside has far softer color.

Start with the inside petals alternating petals as you paint. Since you pre-wet each petal prior to applying color if you didn't alternate the petals the colors would most likely bleed together. Use the angular brush and pre-wet the entire petal with clean water. Be sure to have a practice scrap to test color. On the tip of the 1/2 inch angular brush pick up Thalo Crimson. Place the tip of the brush toward the center pulling down to the end of the petal. Repeat the step pulling down the other side. To achieve a deeper value you may need to repeat this a couple of times or apply a little Alizaren Crimson in the same manner. For lighter area in the center of each petal wipe out color with a clean dry brush while the petal is still wet. While the petal is still damp place on dots with the tip of the angular brush that has been put in Thalo Crimson and Alizaren Crimson or Thio Violet. There are more dots towards the center and they fade out towards the end of each petal. At the very tip of some petals you might want to add a touch of Hookers Green Deep.

Pre-wet with clean water the backside of each petal working one at the time. You can always continue to deepen the values but start out light. Dilute the Thalo Crimson to a soft pink, apply deeper color towards the tip of the brush and pull down both sides of the centers. Pull up a hint of diluted Hookers Green Deep from the area just next to the stem. Add a hint of diluted Hookers Green Deep to the center vein. Try to achieve both hard and soft edges on the vein area.

Create shadow on the curl backs. First pre-wet the curl with clean water. Apply diluted Thalo Crimson. Touch the dirty brush into Cobalt Blue and make a pale lavender, apply under the curl.

LEAVES

Refer to the photo for help with color placement. Pre-wet each leaf prior to applying paint with the angular brush. Apply Hookers Green Deep with hints of Thalo Blue and Thalo Green. Deeper values are made using a mixture of Hookers Green Deep with a hint of Indigo. Wipe out veins with a clean dry brush. Add a hint of Chinese White to vein if necessary.

MISKIT

Remove Miskit with care. Go slow and pull lightly to remove using masking tape. Make sure the paper is dry prior to removal.

STEMS, PISTOLS, STAMEN

Using a round brush or your liner, apply variations of diluted Hookers Green Deep and hint of Indigo to form the stems. Lift out color using a damp brush if they appear all the same value.

Using Cadmium Orange tap on the top of the stamen. While this area is still damp come back and tap Burnt Sienna to the lower section to create a shadow.

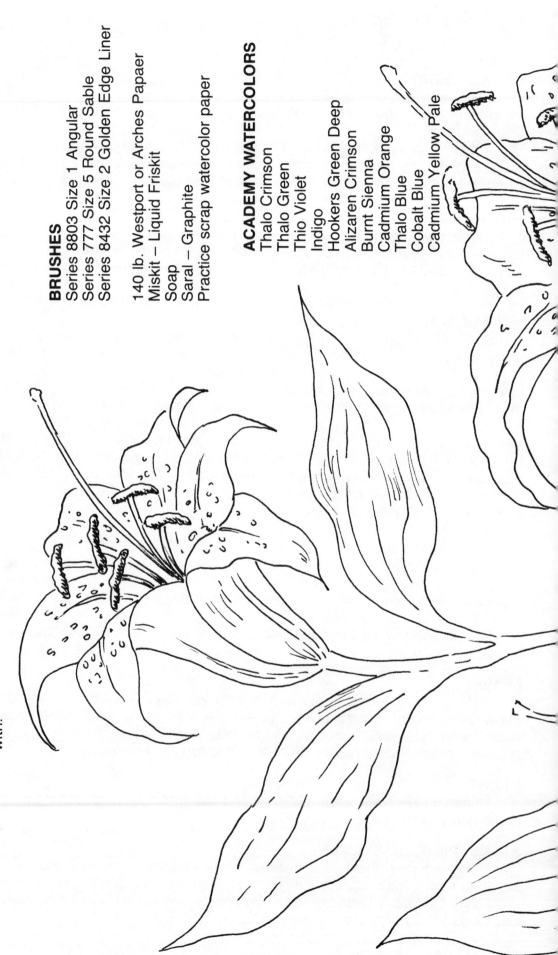

72

LILIES

Lilies come in so many beautiful colors but this color combination is one of my favorites. Transfer the painting guide with care using medium pressure.

Prior to painting apply Miskit, a blocking agent. First apply hand soap on a 5 round sable to make a coating to protect the hair. Dip in Miskit and apply to the pistol and stamen stem and top. Allow this to dry prior to painting. Be careful as these areas will appear white after the Miskit is removed. Don't remove the Miskit until the remaining flower has been painted and dried completely. Should you try to remove the Miskit when wet it could tear the paper. Remove the Miskit with a rubber cement eraser or lightly tap with drafting tape.

Have two containers of water. One to rinse your brush and one with clean water to pre-wet areas with.

BRUSHES

Series 8803 Size 1 Angular
Series 777 Size 5 Round Sable
Series 8432 Size 2 Golden Edge Liner

140 lb. Westport or Arches Papaer
Miskit – Liquid Friskit
Soap
Saral – Graphite
Practice scrap watercolor paper

ACADEMY WATERCOLORS

Thalo Crimson
Thalo Green
Thio Violet
Indigo
Hookers Green Deep
Alizaren Crimson
Burnt Sienna
Cadmium Orange
Thalo Blue
Cobalt Blue
Cadmium Yellow Pale

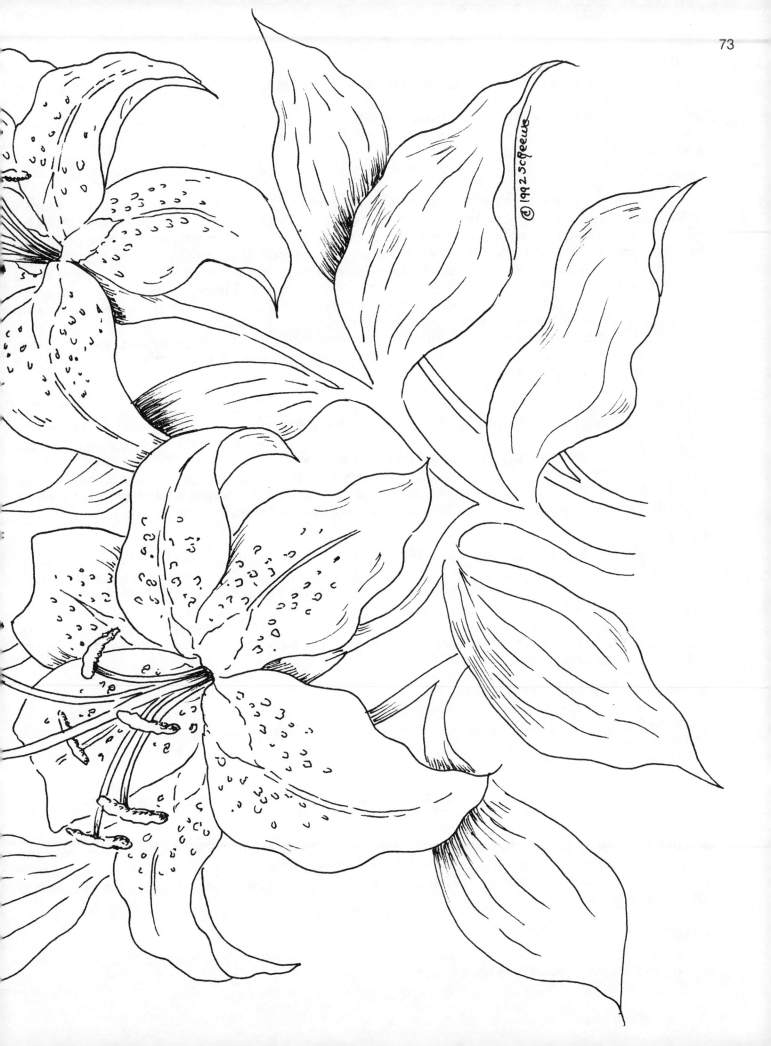

FUCHSIA

BACKGROUND

Pre-wet with clean water the background area surrounding the leaves and fuchsias. Pick up a tiny bit of diluted Thalo Crimnson and paint a light wash around the leaves and flowers. Look at the photograph for reference and do not paint in the shadows; that will come in a later step. Allow your paper to dry before continuing on, this will assure that the leaves and petals do not bleed into the background when you paint them.

LEAVES

In this step you will be adding the first layer of color on the leaves. They are painted in a series of color applications referred to as glazing. It is important to paint the first layer of color on all of the leaves in one sitting; this will give them a common expression and make them look as though they belong together. Plus, you will want to work fast enough on each leaf so the color will blend.

Use your angular brush to pick up Hookers Green Deep. Pick up more paint on the point of the brush. Use the point of the brush along the outer edge of the leaf when painting. Keep the entire surface of the brush to the paper, and vary the leaf shapes. Pay attention to which leaves are forward and those that fall behind when making the edges darker.

With a liner paint in the beginning of the stems to the top of the flower pod using Hookers Green Deep. Do not make the stems too thick, try a few stem lines out on a test sheet of paper before applying them to the painting.

LOWER FUCHSIA PETALS

With your angular brush, pick up Thio Violet, Violet and a touch of Thalo Crimson on the point of the brush, blending towards the back of the brush. We will use this to create the lower petals on the fuchsia. Think of the lower petals as being gathered like fabric, plus vary the color otherwise they will appear flat. Start by adding the darkest color underneath the top cap of petals. You will want to keep your brush flat to the paper, with the point facing the darkest edges. There is a lot of twisting the brush to create the ruffles. Be careful not to overwork the petals, you want them to have a light feel to them.

TOP PETALS

Vary the color of the top petals with Thalo Crimson, a touch of Violet and a touch of Cadmium Red Light. Load more paint on the tip of the brush blending the color out. Look at the photograph to place the lights and darks. Keep the brush flat to the surface, twisting it to create the shapes. Use a light touch so they do not become overworked. Next paint the unopened buds.

Using a liner, pick up Thalo Crimson to paint the stamens. Think of variation in length, do not make them straight, let them curve gently and add a dot at the end. Look at the photogrpah. Do not make the dot too pronounced or heavy.

STEM ATTACHMENT AND LEAVES

You will want to make sure the fuchsia flower has dried before adding the knob that attaches the flower to the stem. Use the very tip of your angular brush to apply Hookers Green Deep and a touch of Thalo Green.

When painting the leaves, think of which leaves are forward and those that fall behind. To achieve the illusion of veins and dimension, we will use a technique called glazing; layering color. Look at the photograph. Some veins are created by allowing a thin line of the underlying lighter color to show through, others by overlapping color, and some with shading.

Begin with apply Hookers Green Deep as a first wash of color, allow this layer to dry before adding any of the following colors. Use variations of Hookers Green deep and Thalo Green to glaze over the leaves. Apply layers of color to achieve depth and richness. You will want to add touches of Thalo Crimson to the leaves, as well as the left edge of some of the larger stems. Look at the photograph for reference.

SHADOW

As a final touch you will want to add the shadows with a light diluted wash of Indigo. Paint the shadows to the left. Look at the photograph.

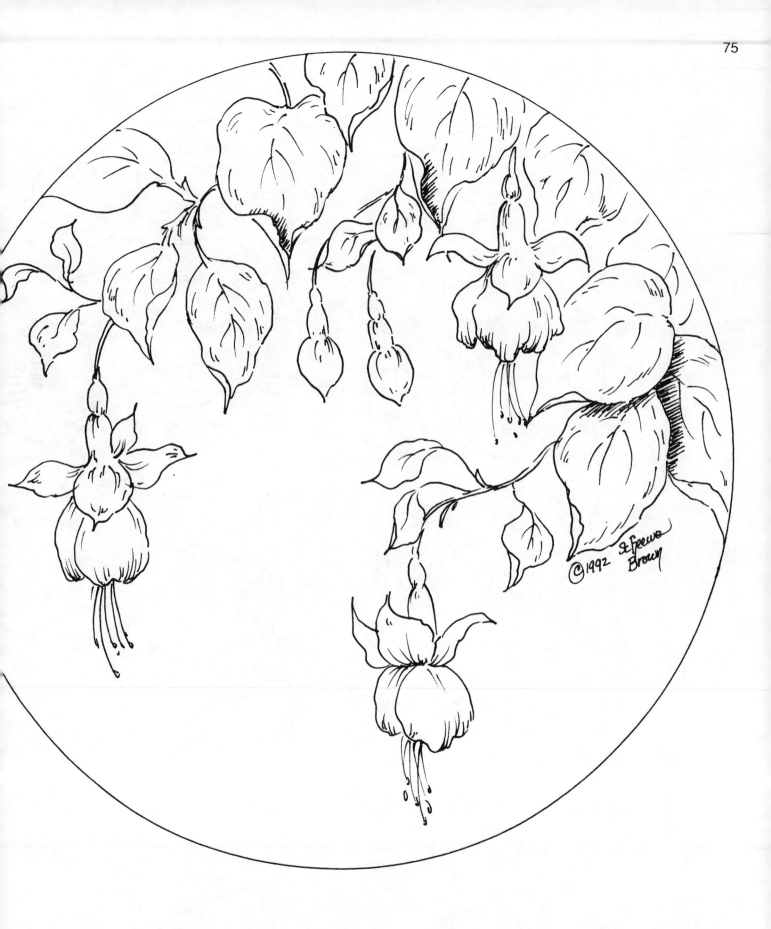

©1992 St. James Brown

These beautiful flowers come in so many color variations, it's hard to pick a favorite variety.
Bring a touch of Summer into your home doing a large painting or a smaller version. Use a portion
of the design to make book marks or greeting cards.

FUCHSIA

© 1992
Scheewe
Brown

WATERCOLOR PALETTE
Thalo Crimson
Thio Violet
Cad. Yellow Pale
Cadmium Red Light
Thalo Green
Hookers Green Deep
Raw Sienna
Violet
Indigo

BRUSHES
¾ or 1 inch Synthetic Flat
Size 1 Liner
½ inch Angular Brush

Test Paper

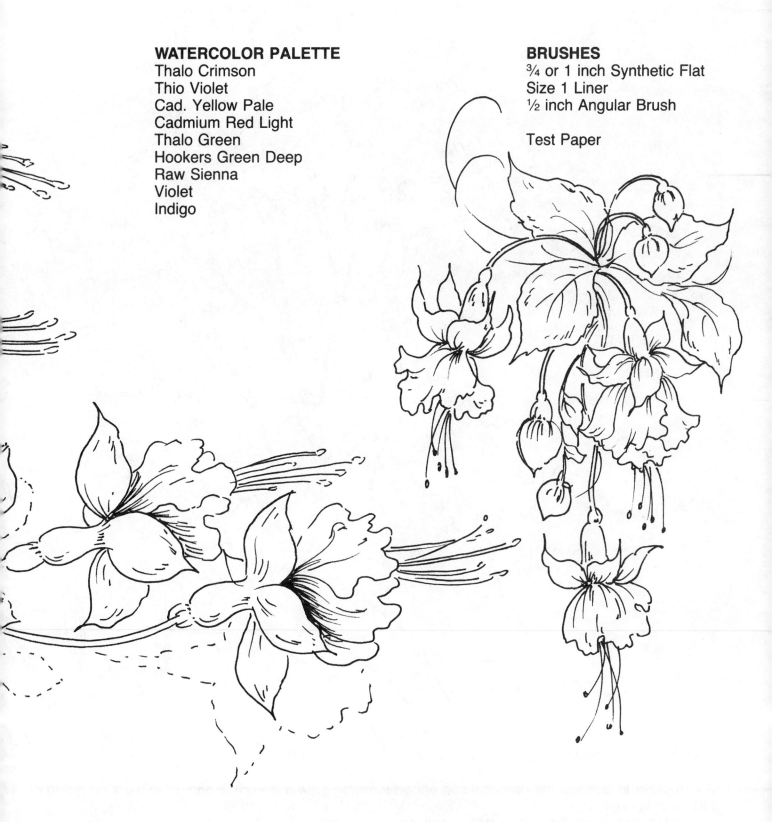

Trace the pattern onto the watercolor paper with either Saral graphite transferring paper or a graphite pencil. Be careful not to press hard when transferring the pattern as it is easy to dent the paper. If you do dent the paper, color will flow into the recess and it will show as a dark mark.

But, I would like to add that sketched pencil lines are often a part of traditional watercolor, it is all in what you prefer.

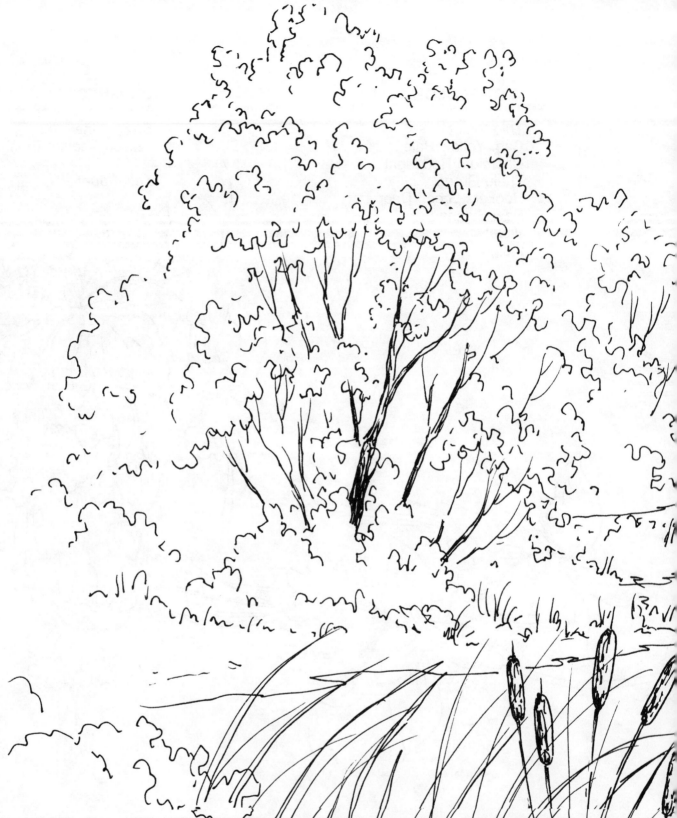

In order to achieve the beautiful soft edged morning glow it is very important to work on a 260 or 300 lb. cold pressed.

Lightly sketch on the design with a soft graphite pencil or transfer the painting guide using Saral. This painting is fun, easy to accomplish and can be done using a variety of colors. Try making some greeting cards or small paintings to test colors and get a feel for the wet on wet technique.

PREPARATION

Prior to starting your painting soak the surface using a sponge or 1½ inch brush. Be sure to get this evenly wet. The heavier paper will hold the water longer allowing the soft diffusion of color. You'll need to work fast as the wet on wet technique requires the dampness of the paper. Read all the instructions prior to wetting the paper.

HAZY DAWN

WATERCOLOR PALETTE
Thio Crimson
Thio Violet
Violet Thalo Purple
Cadmium Yellow Medium
Hookers Green Deep
Burnt Umber

BRUSHES
1 or 1½ inch Flat
Size 1 Liner
½ inch Foliage Brush

Sponge
260 or 300 lb. Coldpressed

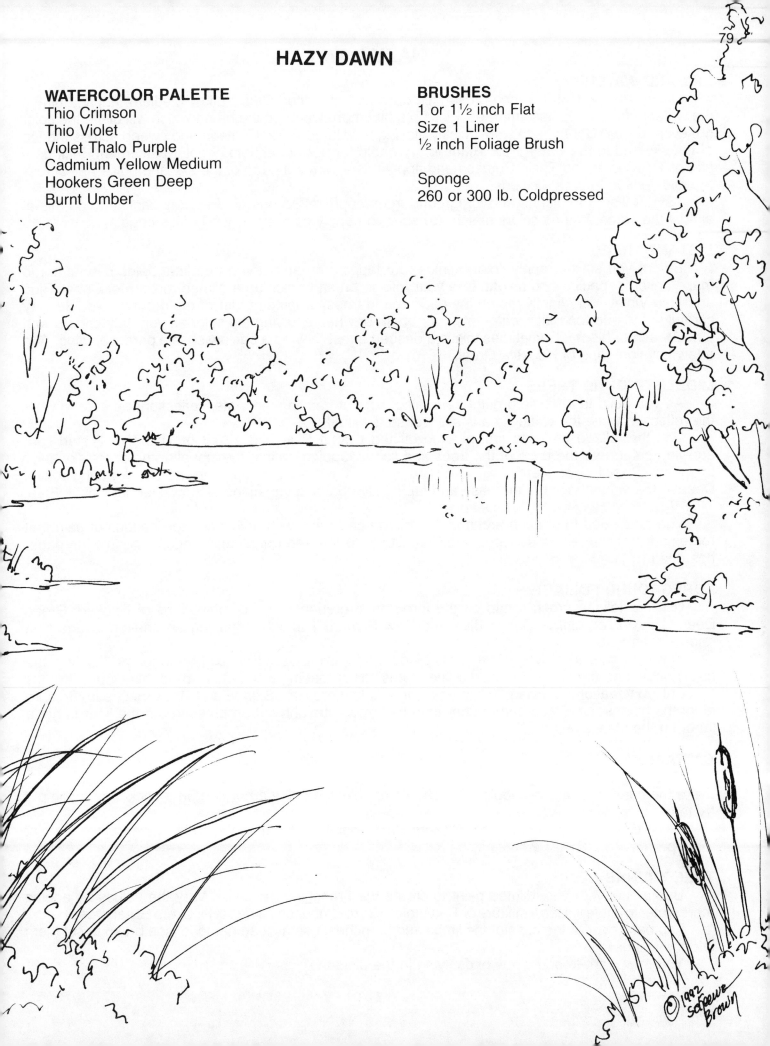

© 1992 Soreece Brown

HAZY DAWN

SKY AND WATER

Using a large 1 or 1½ inch brush pick up a hint of diluted Cad. Yellow Medium, apply a hint in the water in front of the distant trees. Pick up a hint more water on the brush which will dilute the color out even further. Continue to work quickly picking up diluted Thalo Crimson and sweep across the top of the sky and in the water area. Refer to the photo for additional help of color placement. Pick up a hint of Thio Violet and Thalo Crimson and apply this again at the top of the sky and pull a hint across the mid-section to create clouds.

As you work the distant and foreground trees apply reflections as well. It is easiest to do this at almost the same time as colors match. Be sure you apply color up to the bank's edge.

DISTANT TREES

Before you start to apply color, think about tapping on an uneven tree line, being careful not to make uniform spacing and height. Use your foliage brush to pick up a diluted mixture of Cobalt Blue and Thio Violet. Very lightly tap on the background trees, tapping harder at the ground area. Be very careful not to add too much water into your brush or when applying the color as you may end up with a backwash or bloom. Sometimes this is a desired effect, having a backwash is a personal thing. Add a few tiny light taps of Hookers Green.

MIDDLE GROUND TREES

As you build the middle ground trees also work at painting the water reflection; be sure to work the reflection while the water area is still wet so it will diffuse.

Use the foliage brush to first pick up diluted Cobalt Blue and a hint of Thio Violet, start light applying paint near the base of the trees and lightly tapping up into the sky allowing some sky color to appear. Do not be concerned with detailing the trees at this point, tap on the soft background colors. Deepen the values towards the base and tap lightly up using variations of Raw Sienna, Cobalt Blue, Thio Violet and Hookers Green Deep.

You may need to deepen areas in the foliage and trees with additional applications of paint but remember to leave some sky area showing. Don't do the tree trunks and limbs, wait until the paper has dried.

FOREGROUND FOLIAGE

Use the foligae brush to tap on the foreground greenery with combinations of Hookers Green Deep, Thio Violet, hint of Cobalt Blue and Raw Sienna. Tap lightly making an uneven foliage line, refer to the photo.

Use your liner to draw out the grass blades, be sure to vary the height and length. By now the paper should be dry enough to hold a line, if it is still spreading wait longer to do this step.

Pull up variations of foliage mixtures using a little more Raw Sienna and Hookers Green. Be sure to let the blades curve and bend rather than being too straight. Lift up pressure on the liner to get a taper on the blades.

CATTAAILS

Paint the cattails using a liner, pick up Thio Violet and a hint of Burnt Umber. Be careful not to make the cattails fat in the middle, they should appear more like a hot dog on a stick than a blimp. I try to get uneven clusters.

Using diluted Burnt Umber and Hookers Green paint the stem on the cattails, extend the stem at the top.

TREE TRUNKS

Use a liner with very diluted paint to create the branches and limbs, vary the values by adding more water to dilute it. Use a mixture of Thio Violet, Burnt Umber and a hint of Hookers Green Deep.

Tap back over at the base of the limbs and branches, use a clean damp foliage brush to set them into the foliage.

You may want to add a few birds flying in the distance.

HAZY DAWN

© 1992
S. Reeves
Brown

CATTAILS

WATERCOLOR PALETTE
Cadmium Orange
Cadmium Yellow Medium
Hookers Green Deep
Cobalt Blue
Magnesium Green
Burnt Umber
Thalo Green
Indigo
English Red
Raw Sienna
Manganese Blue

BRUSHES
¾ or 1 inch Synthetic Flat
Size 1 Liner
¾ and ½ inch Foliage Brush
½ inch Synthetic Angular

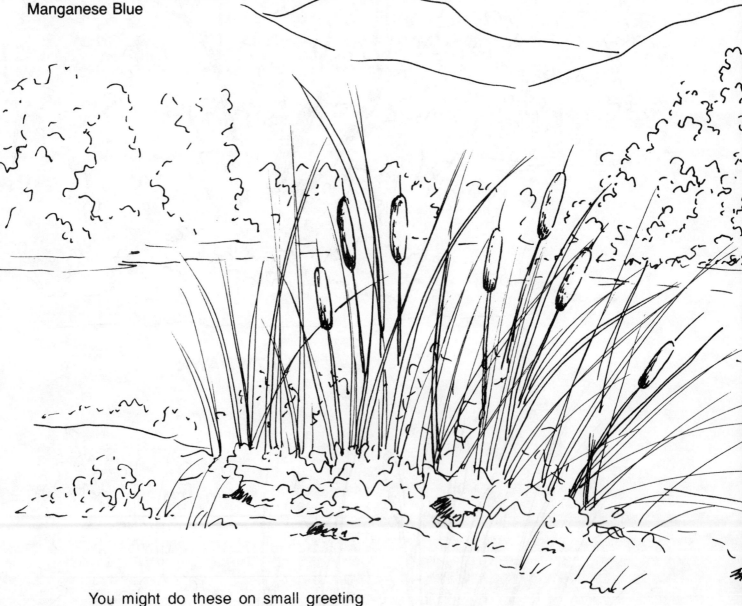

You might do these on small greeting cards to test different colors. Make a variety of color variations on cards to send your friends. Be sure you slip a sample in your notebook for reference.

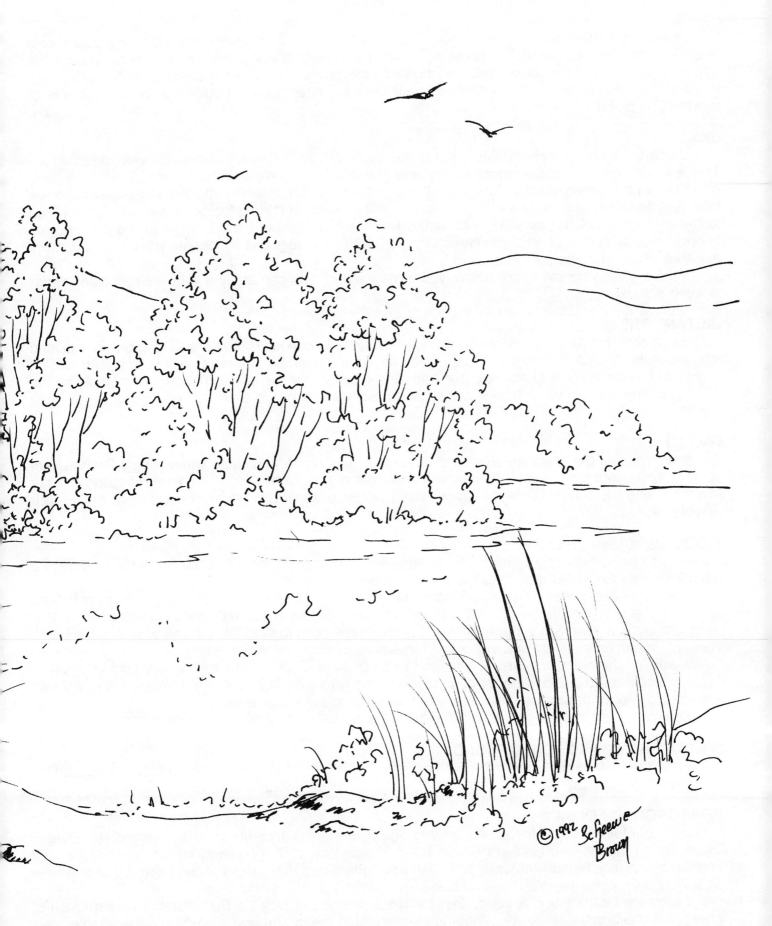

CATTAILS

Trace the pattern onto the watercolor paper with either Saral graphite transferring paper or a graphite pencil. Be careful not to press hard when transferring the pattern as it is easy to dent the paper. If you do dent the paper, color will flow into the recess and it will show as a dark mark.

But, I would like to add that sketched pencil lines are often a part of traditional watercolor, it is all in what you prefer.

SKY

Using a 1 inch synthetic brush, pre-wet the entire sky area down into the hills with clean water. This will help the color to flow more evenly and give a reflective glow to the hill area.

Start with painting diluted Orange and hint of Cad. Yellow Medium into the sky area above the hills, and down into the top of the hills. Next add a light wash of diluted Indigo tinged with Cobalt Blue to the top portion of the sky. Do not overlap too much of the blue and orange or the mixture can become muddy quite fast. But, you can lightly work with them together as long as you do not overwork the area. Brush it in, be light and leave it be.

If the sky area begins to dry before you have finished, you can apply a light wash of clean water to keep it moist.

DISTANT TREES

Begin with painting the distant lighter valued trees. Use your foliage brush to pick up a diluted mixture of Indigo and Manganese Blue. Lightly tap on the background trees; vary their height and be careful not to make them hedgelike. Don't add too much water into your brush, or when applying the color you may end up with a backwash or bloom. Sometimes this is a desired effect, but in this case it is not.

WATER

Next, pre-wet the water area using a 1 inch synthetic brush and clean water. Apply Orange, hint of Cad. Yellow Medium, some Indigo and a very light hint of Cobalt Blue. Think of reflecting the sky when painting the water. While the water is still wet, you want to finish the next step to create tree reflections.

MIDDLE GROUND TREES

As you build the middle ground trees also work at painting the reflection; be sure to work the reflection while the water area is still wet so it will diffuse.

Use your foliage brush to pick up Magnesium Green, Hookers Green Deep and a touch of Indigo; pick up more pigment on the tip of the brush. Do not be concerned with detailing the trees at this point, but lay in a general background area. Deepen the values toward the left side and near the bank. Think of variations in height and value and remember to work the water area.

Wash out the paint from your brush and pick up some English Red with a very light addition of Orange. Look at the photograph for color placement then lightly tap it into the tree area; this will add a warm glow to the foliage. Again add a touch of color to the water area.

You may need to deepen areas in the foliage and trees with additional applications of paint.

DISTANT BANK AND FOREGROUND

Paint the distant bank along the bottom of the trees with Raw Sienna and a hint of English Red using an angular brush. Use this same color variation for the foreground area.

FOREGROUND FOLIAGE

Use your foliage brush to tap on the foreground greenery with combinations of Magnesium Green, Thalo Green, Indigo and Hookers Green Deep. Again look at the painting for reference. Use your angular brush moistened with water to soften the edge along the bottom of the foliage. Let this area sit before painting in the grass and cattails.

To create pebbles and a sandy texture in the foregound pick up Burnt Umber and a touch of green, flick the brush against your finger to spatter it onto the foreground area. You will want to protect the upper part of your painting or you could end up with speckles everywhere. Apply a few larger rocks using Burnt Umber and Burnt Sienna on the angular brush.

Using your liner, draw out some grass blades using a combination of Manganese Green, Thalo Green and Hookers Green Deep. Be sure to paint the grasses so they have a bend to them.

CATTAILS

Paint the cattails with an angular brush; pick up Burnt Sienna and Burnt Umber on the point of the brush. Make the top of each cattail slightly darker to the left edge, vary their height, allow them to bend, and be sure to not paint them too thickly. With a liner paint on the stem and the extended tip.

FINAL TOUCHES

As a final touch, using your liner, add the birds to the sky. And as a final suggestion, do not paint them the same size or make them look like flying M's. Use a test strip of paper to practice a few before adding them to the sky.

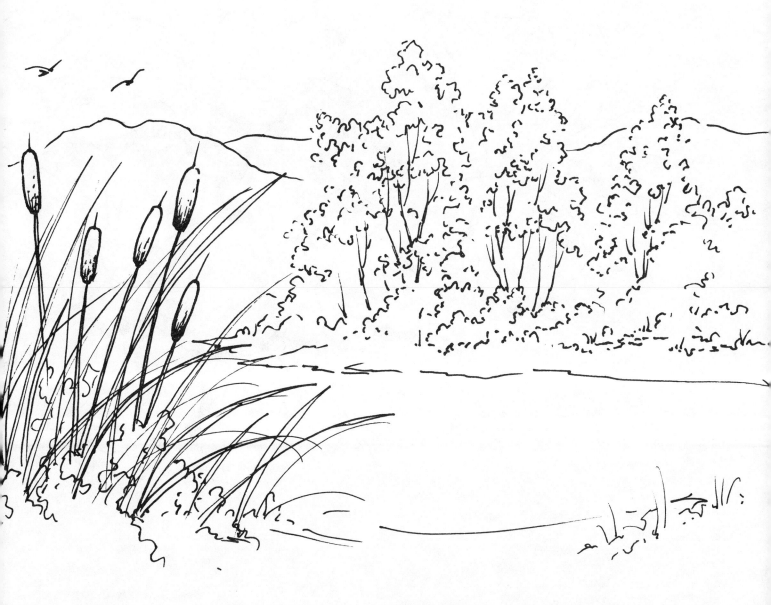

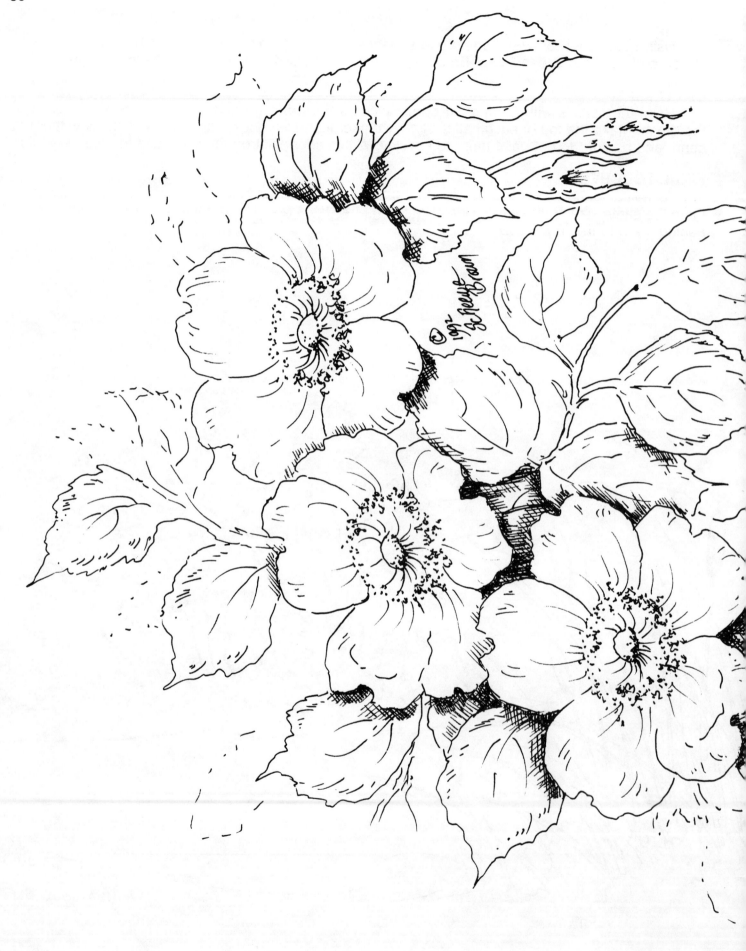

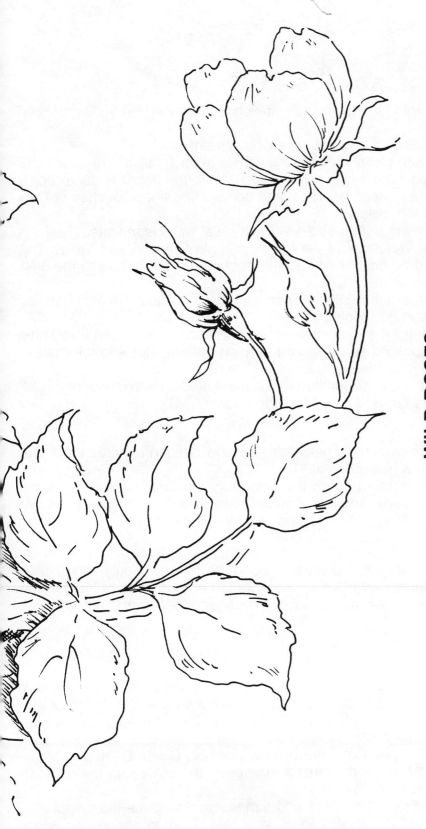

WILD ROSES

BRUSHES
Series 8803 Size ½ Angular
Series 4622 Size ¾ inch
Series 8801 Size 1 Liner

PALETTE
Thalo Crimson
Violet
Cadmium Yellow Pale
Raw Sienna
Hookers Green Deep
Magnesium Green
Olive Green
Thalo Green
Indigo

Transfer the painting guide using Saral Graphite. Be careful you don't press too hard when you transfer the painting guide as you could damage the paper.

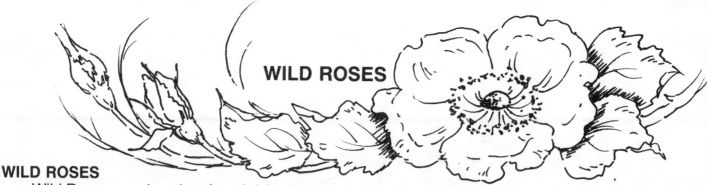

WILD ROSES

Wild Roses vary in colors from bright pinks, soft pinks, delicate white and even yellow. I've painted these using soft shades of pink.

Refer to the photo as you work for additional help with color placement.

Start by pre-wetting a doughnut shape of clean water in the center of each flower one at a time. Leave the very center dry as you will be painting this in a later step. While the paper is damp apply Cadmium Yellow Pale making a deeper shade near the unpainted center. Add a few touches of Raw Sienna toward the lower left over some of the yellow.

Paint one flower petal at a time alternating petals. Pre-wet each petal with clean water. Test the color on a scrap of watercolor paper. Use variations of very diluted Thalo Crimson and Violet. The petal area edging, the yellow center should be deepened slightly. Apply a hint of shadow to the area directly behind each top petal.

To create the appearance of dip in the petal slightly deepen a curve line about 1/4 inch into the petal with a diluted mixture of Thalo Crimson and Violet.

At the edge of the yellow apply tiny dots using variations of Raw Sienna, Sap Green and Thalo Crimson. Start light and add more to the forward section in an uneven pattern. Refer to the pattern for direction and pull out a few lines using Raw Sienna and Olive Green.

In the center button apply a light wash of Olive Green leaving an unpainted area to create highlight. Darken the center to the left using Hookers Green and a hint of Indigo.

BUDS

First apply the pink values using a light wash of Thalo Crimson and deepen towards the base, use a little more Thalo Crimson mixed with a hint of Violet.

Use either a liner or twist the angular shader to form the outside green area. Start with diluted mixture of Hookers Green Deep and Green Olive. Add a hint of Magnesium Green. Deepen the calyx at the base using additional Hookers Green Deep, Olive Green and hint of Violet.

BACKGROUND

Begin pre-wetting with clean water the background areas around the flowers. Apply very diluted washes using variations of Magnesium Green, Olive Green, Hookers Green and hints of Indigo. The idea is to create a soft diffused background with a few suggestions of leaf shadows. (Refer to photo.)

LEAVES

Try not to rush the leaves. Slowly build up color on all the leaves rather than completing one leaf at a time. Use an angular brush placing the point of the brush in pigment then place the point of the brush toward the outside edge. Next place the point of the brush in the center of the leaves to create veins. Lift out color with a dry brush if the area becomes too dark.

The leaves start with variations of light washes of Green Olive, Hookers Green Deep and Magnesium Green. As you continue to work add additional glazes to deepen the values. In the darkest area add Indigo to the Hookers Green and Green Olive mixture.

Often I pull the flower color into the leaves. This helps add dimension and gives the painting a more realistic look. It is helpful though to test this next step on your test paper to assure this is an addition you would like. Paint the same mixture of colors used on your leaves and apply it to your test sheet. Once it has dried add a diluted hint of Thalo Crimson over the green. If you like this appearance you can add hints of Thalo Crimson to a few leaves.

SHADES OF BLUE AND LAVENDER

MISKIT

Prior to painting apply Miskit, a blocking agent, to the daisies. It's important to apply hand soap on a 5 round sable to make a coating to protect the hair. Dip the brush in Miskit and apply making stroke daisy petals. Don't remove the Miskit until the leaves, background and violets have been completed. Wait until the paper is dry to avoid a possible tear in the paper. Remove the Miskit with rubber cement eraser or lightly tap with drafting tape.

BACKGROUND

Begin with pre-wetting the entire background with clean water with the exception of the flowers and buds. Be sure to wet around them. Start at the top of your paper and begin to apply the background tones, remember it is always easier to start light and work darker. Pick up hints of Violet, Thio Violet, Cad. Yellow Medium and Cobalt Blue. Re-wet the paper as you go along. Refer to the photo for help with placement.

VIOLETS

Start with the large lower flower petal pulling out just a little Cad. Yellow Medium. With a clean 1/2 inch angular pick up Thio Violet on the point of the brush. Apply the point to the outside edge as you create each petal coming back with the slightest hint of Violet.

Use the liner or point of the angular brush picking up Violet to create the eye on the face.

LEAVES

The leaves are painted using a 1/2 inch angular brush. Apply diluted washes starting with a mixture of Lemon Yellow, Cad. Yellow Medium and Cobalt Blue.

Come back with glazes using hints of Thio Violet and Violet.

Apply shadow areas using Indigo and Hookers Green. Add these glazes slowly allowing bottom layer to be dry.

Apply a vein using a liner with Chinese White if necessary.

DAISIES

When the Miskit is lifted it also removes the painting guide so retrace the daisy petals and centers. Base the center using an angular brush, pick up Cad. Yellow Medium with the tip of your brush. Applying paint to the tip of your brush will create a nice graduation of color. Next apply a slight shadow with a touch of Thio Violet, Orange and Burnt Sienna.

DAISY PETALS

Have a sheet of test paper handy. Pick up the pigment with point of your angular brush. Use variations of Violet, Thio Violet, hints of Indigo and Hookers Green.

Avoid painting one petal next to another since they would both be wet and could bleed into each other. Remember, it is far easier to darken than to lighten, so start light and slowly add more variations of pigment.

STEM

Use a liner for the stems. Apply variations of leaf colors. When in doubt, paint light, add hints of yellow for a highlight.

VARIATIONS

It's very difficult to do two paintings alike and with watercolor, it's even harder. Try to plan ahead. Test color on paper prior to the surface. Try small variations making note cards or greeting cards.

Hope you enjoy watercolor.

SHADES OF BLUE AND LAVENDER

ACADEMY WATERCOLOR
Chinese White
Thio Violet
Thalo Crimson
Violet
Cobalt Blue
Hookers Green Deep
Indigo
Lemon Yellow
Cadmium Yellow Medium
Cadmium Orange
Burnt Umber
Burnt Sienna

BRUSHES
Size 1 inch Synthetic Flat
Size 1 Liner
Size ½ inch Angular

Miskit
140 lb. or 260 lb. Paper
Soap
Saral Graphite
Practice scap of paper

Transfer the painting guide using Saral Graphite. Be careful to use medium pressure when you transfer the painting guide as you could damage the paper.

DAISY BUCKET

WATERCOLOR PALETTE
Indigo
Burnt Umber
Burnt Sienna
Raw Sienna
Cadmium Yellow Pale
Cadmium Yellow Medium
Hookers Green Deep
Cobalt Blue
Thalo Green
English Red
Cerulean Blue

© 1992 Scheewe

BRUSHES
Size 5 Round Sable
Size 1 1/2 or 1 inch Synthetic Flat
Size 1 Liner
Size 1/2 inch Angular Shader

Test Paper
140 or 260 Cold Press

DAISY BUCKET

Trace the pattern onto the watercolor paper with either Saral graphite transferring paper, or a graphite pencil. Be careful not to press hard when transferring the pattern as it is easy to dent the paper. If you do dent the paper, color will flow into the recess and it will show as a dark mark.

But, I would like to add that sketched pencil lines are often a part of traditional watercolor, it is all in what you prefer.

MISKIT

Before beginning this painting you will first need to apply Miskit to all of the daisy petals and forget me nots.

This is a very important step, before dipping your #5 round brush into the Miskit, you must first wet it with water, then stroke it against a bar of hand soap to coat it. Then, dip your brush into the Miskit and apply it to each daisy petal and forget me nots. After this step, you will need to allow the Miskit to dry completely, 20 minutes to an hour depending upon the humidity.

WOOD

Start by pre-wetting the farthest right plank of wood with your 1 inch synthetic brush, make sure that is good and moist, evenly wet but not runny with water. Be careful not to wet the bucket area and leave the area where the leaves are white. You will want to paint around and behind the daisies that extend out from the bucket against the barnwood. You want there to be contrast around the daisy petals so they stand out from the background. Be sure though, to not paint over what would be the stems.

In this step we are creating a diffused foundation for suggesting wood grain. We will be building the illusion of wood with layers of paint, so do not be concerned with bringing this step up to a finished level at this point.

With your 1 inch synthetic brush pick up Indigo, a tap of Burnt Sienna and a tap of Burnt Umber. With these colors suggest the woodgrain and contours of any knot holes in sweeping vertical strokes, with jagging movements. It will help to tilt your paper horizontally. You may need to make a couple applications of color while this area is still wet to create the deeper tones. Look at the the photograph. Before this area dries, pick up some Indigo, use the brush against your finger to splatter the area along the wood grain. Repeat this same process on each plank of wood.

To create the division between boards, use your angular brush to pick up some Burnt Umber and a touch of Indigo. With the brush on its chisel, paint in the crack between boards. Be sure to look at the photograph. You will see in the photograph that the cracks are uneven, there are jags, knot holes and variations in width; keep all of this in mind when painting.

PAIL

Pre-wet the pail area with clean water, be sure not to paint over the leaves. Pick up Burnt Sienna and apply it to the left edge of the pail, graduate it from darker on the left to lighter on the right. You will also want to paint the areas under the leaves and flowers darker to suggest shadows. You may want to add a touch of Indigo to the areas you would like deeper in tone. On the very right edge of the pail, add a light shadow, this will help give dimension to the pail.

SHADOWS

After the pail has dried apply shadows cast from the daisies and bucket onto the barnwood. Keep in mind the direction the light is coming from. Pick up Indigo and apply it to the left of the leaves, flower and pail. Look at the photograph for placement of the shadows.

LEAVES

Start with Hookers Green Deep on your angular brush and loosely paint in the leaves; add touches of Cad. Yellow Medium and Thalo Green. Think of creating light and dark areas on the leaves depending on what is forward and what is behind. If you get an area too dark, it can be lightened with Chinese White. Be sure to paint in the areas between the flowers, or you will end up with unwanted patches of white. As a final touch you want to add a "few" details such as veins on a couple of leaves, and you may feel the need to lighten or darken some areas.

REMOVING MISKIT

Let the leaves and the area surrounding the flowers completely dry; at least a couple of hours depending on the humidity. If you do not let the paper completely dry you will end up tearing it when you attempt to remove the Miskit. When you are ready to remove the Miskit from the daisies, the forget me nots and stems, use masking tape to lift it off.

DAISY CENTERS

When the Miskit is lifted it also removes the painting guide, so retrace the daisy petals and centers. Base in each center using Cad. Yellow Pale on the tip of your angular brush. To the left on the center you will want to make a graduation with Cad. Yellow Medium. Look at the photograph for reference. Next apply a slight shadow with a touch of Burnt Sienna on the tip of the brush. Tap along the bottom leftish edge of the center while it is still wet so the color will diffuse inward a bit. In each center tap in the suggestion of a dent with a hint of Burnt Sienna.

DAISY PETALS

Have a sheet of paper near by to test your colors. Use variations of Paynes Gray, Cerulean Blue, and Sap Green on the tip of your angular brush, you may also want to add a tiny hint of Burnt Umber. Touch your brush to the edge of each center and slide the color outward. Avoid painting one petal next to another since they will bleed together, so paint every other petal as you work. Remember, it is far easier to darken than to lighten, start light and slowly add more pigment.

STEMS

Use a round brush to form the stems. Apply variations of Hookers Green Deep, Thalo Green and slight touches of Cad. Yellow Medium and Cerulean Blue. When in doubt, paint light, as you can always deepen a color. Should an area become too dark, while it is still wet you can use an almost dry brush to come in and lift out some color.

FORGET ME NOTS

As a final touch pick up Cobalt Blue and a touch of Cerulean Blue. Lightly tap in the flowers.

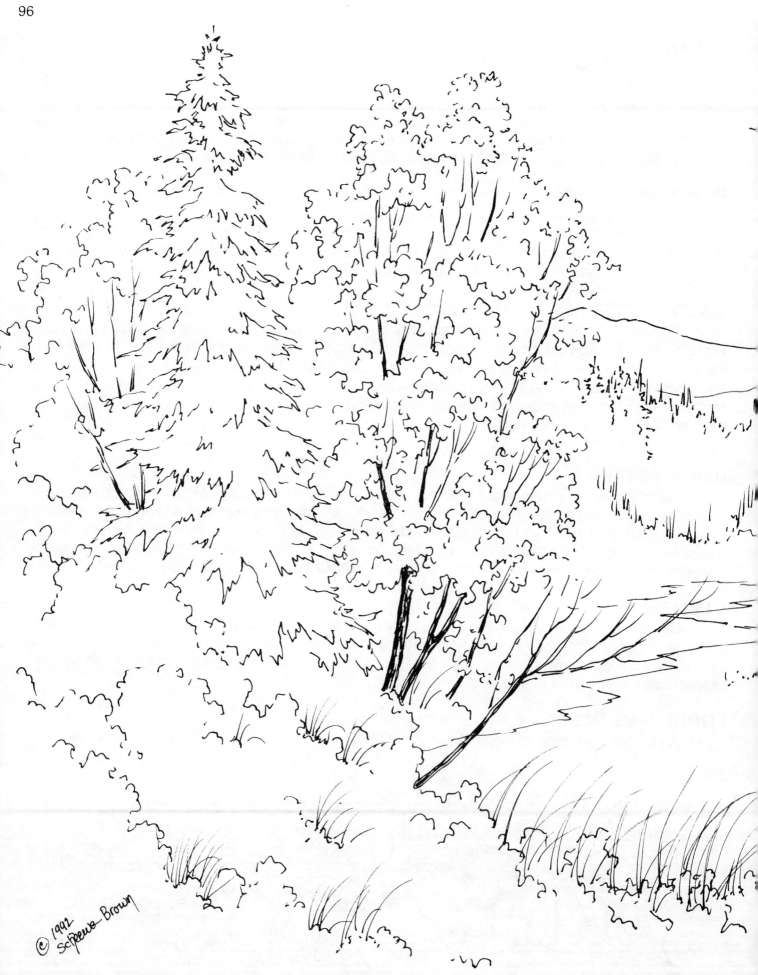

© 1992
Schreve Brown

SUNRISE — SUNSET REFLECTIONS

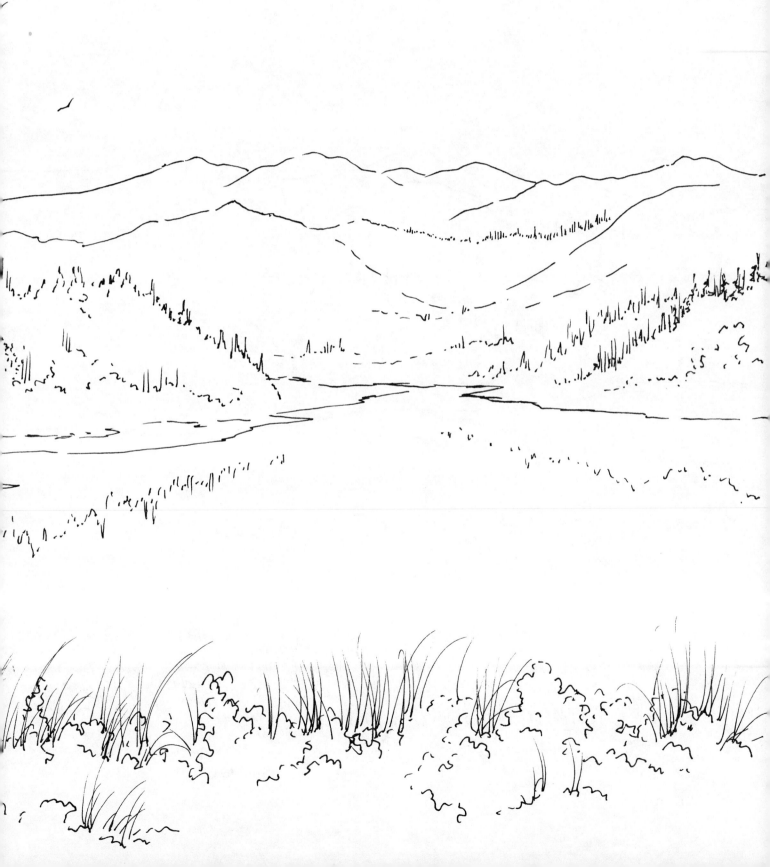

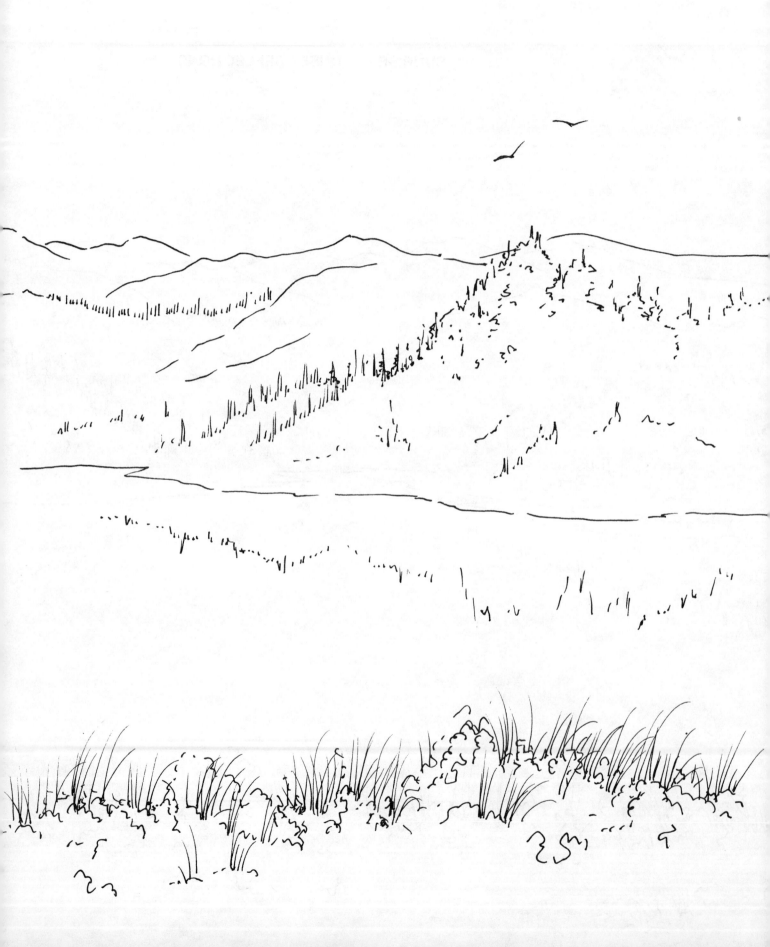

WATERCOLOR PALETTE
Cadmium Yellow Pale
Cadmium Orange
Thalo Crimson
Thio Violet
Violet
Thalo Blue
Cobalt Blue
Indigo
Raw Sienna
Hookers Green Deep

BRUSHES
¾ or 1 inch Synthetic Flat
Size 1 Liner
Size ½ Angular Shader
Size ½ Bristle Angular Foliage Brush
Size ¾ Bristle Angular Foliage Brush
Size 2 or 3 Fan

Paper 260 Winsor Newton Coldpress

Trace the pattern onto the watercolor paper with either Saral graphite transferring paper or a graphite pencil. Be careful not to press hard when transferring the pattern as it is easy to dent the paper. If you do dent the paper, color will flow into the recess and it will show as a dark mark.

But, I would like to add that sketched pencil lines are often a part of traditional watercolor, it is all in what you prefer.

SKY

Pre-wet the sky area with clean water down to the top of the hill area.

To create the sky, you will be making a series of washes. Start with Cad. Yellow Pale on your ¾ flat Golden Edge; apply a wash from the right towards the center and across the top of the hills. Next pick up Cadmium Orange, brushing it just above the horizon into the hill area and across to the area that will reflect through the trees. Pick up Thalo Crimson, lay a wash in at the horizon and up behind the trees. You may need to re-wet the upper sky area, if it begins to dry, with a light wash of clean water. Rinse your brush out and pick up a hint of Thalo Blue, applying it to the upper left-hand corner; be careful, this color can become very bright. Look at the photograph for reference.

Next we will be adding the suggestion of thin clouds with Thio Violet. Look at the photograph for placement. Remember, the lower clouds are thinner, the upper ones a slight bit thicker.

WATER

Pre-wet the water area until it has a glossy, but not puddled appearance. We will be following basically the same steps as with the sky; think of reflecting the sky colors. Begin with Cad. Yellow Pale, following with Cad. Orange, Thalo Crimson, Thalo Blue with suggestions of Thio Violet. Along the edges of the water where it meets the bank you will want to add Violet and Thio Violet. Look at the photograph.

Add Indigo, Violet and a touch of Thio Violet along the bank where the trees will reflect into the water. Gently pull down the color to create the reflection. Look at the photograph. Do not pull down too long of reflection into the water, as in a later step we will return to this area and add deeper tones with dry brush effect.

HILLS

Wait until the sky area has dried before painting the hills. Allow the distant hills to remain lighter, and the hills in the foreground to appear darker; this will give the illusion of distance and space. You will also want to allow some of the undercolor from the sky to show through; this will create the illusion of color reflecting off the hills.

With an angular brush, pick up Violet and Thio Violet, load the point of the brush with more paint. Test your color on separate piece of paper, since we will be glazing color over color. Use the point of the brush along the top edge of the hill, contacting the entire surface of the brush with the paper. If the color becomes too dark, you can blot it with a paper towel while it is still wet; or you can use a dry brush to lift out some of the color. You will also want to add touches of Thalo Crimson, Thalo Blue and Cadmium Orange. Look at the photograph for color placement.

As a final touch, you may need to come back and add darker tones with another application of color, as watercolors always dry lighter.

SUNRISE — SUNSET REFLECTIONS

TREES

After the hill areas have dried, paint the middle around trees on both sides, working one side at a time, starting with the left side. Scrub in color to what would be the base of the tree line with Cobalt Blue and a mixture of lavender; being a combination of Violet and Thio Violet. Look at the photograph. Be careful to only scrub in the area where the trees are, do not over extend it. While the area is still wet, load your brush with Indigo and Violet. In vertical upward strokes, pull up the top of the trees. You may need to tap your brush a few times to get the hairs to separate out. Think of varying the value in the trees and at the same time dry brush into the water area the tree reflection.

On the left bank between the trees and the water, use a clean brush with Thalo Crimson and a hint of Cadmium Orange to soften the ground between the two.

Repeat the same process painting the trees on the right side, pay attention to the foreground and background trees. You will also want to add a touch of Hookers Green Deep to the trees. Look at the photograph.

Use the pigment already on the brush to soften the edge along the bank; the paint may need to be diluted with water.

FOREGROUND

Using your foliage brush, tap on the foreground area with Indigo, Violet and touches of Hookers Green Deep. Also make some upward strokes to give the appearance of grass. In order to make the foreground darker, you will have to come back in after it has dried and apply another layer of paint.

In the left area of the foreground, you will want to scrub in a light diluted wash of Hookers Green Deep with touches of Violet and Indigo. Look at the photograph. You will want this area to look like light is reflecting into it.

LEFT FOREGROUND AND TREES

Begin with lightly tapping on the left foreground tufts of grass using Indigo, Hookers Green Deep and Thalo Blue. It may be difficult to distinguish between the middle tones and darks; if you squint your eyes, it will help to separate the light and darks in the painting.

Next, using the foliage brush, tap on the leaves of the deciduous tree using Violet and Indigo. You will need to tap your brush on a separate piece of paper to separate out the hairs before you apply the pigment to the painting. Be sure to paint the foliage airy and open.

Using your 1/2 inch angular brush, pick up Hookers Green Deep and Indigo. You will want to tap your brush against a test sheet of paper a few times to separate out the hairs. Start with the top of the fir tree and begin tapping on the limbs as you work down the trunk. Be careful to not make the limbs a solid block of color, but let the light break through the boughs. Look at the photograph.

BRANCHES

Once the foliage and foreground have dried, use a size 1 liner to pick up a dark wash of Indigo and Violet. Paint the branches into the tree with upward motion. Look at the photograph.

At this time you will also want to add some gently swaying blades of grass.

BIRDS

As a finishing touch we will add birds into the sky area. Be careful to not make them look like flying 'M's. Use a light touch with the branches. Remember birds in the distance always look smaller; be aware of painting them different sizes.

Use your size 1 liner to pick up a fluid mixture of Indigo. Test your color, and practice on a separate sheet of paper. And once again, take another look at the photograph.

VIDEO

'"**THE GIFT OF PAINTING, SIMPLY WATERCOLOR**" VIDEO - By Susan Scheewe Brown. Guided instruction through tools and techniques for the beginning watercolorist.......................................$24.95_____

"**THE GIFT OF PAINTING**" VIEDO - By Susan Scheewe Brown. Problems and solutions when painting oil landscapes. The video runs 90- minutes while two landscapes are completed................$24.95_____

Please ad $3.00 for handling and postage per tape.
Sorry, but we must have a " No Refund - No Return" policy.

BOOK LIST

_____	Vol. 1	"His and Hers" by Susan Scheewe	101	$6.50	_____
_____	Vol. 5	"So Dear To My Heart" by Susan Scheewe	105	$5.50	_____
_____	Vol. 6	"Brushed With Elegance" by Susan Scheewe	106	$5.50	_____
_____	Vol. 7	"Paint 'n Patch" by Susan Scheewe	107	$5.50	_____
_____	Vol. 11	"I Love To Paint" by Susan Scheewe	111	$6.50	_____
_____	Vol. 14	"Enjoy Painting Animals" by Susan Scheewe	114	$6.50	_____
_____	Vol. 17	"Countryside Reflections" by Susan Scheewe	161	$6.50	_____
_____	Vol. 18	"Mostly Landscapes" by Susan Scheewe	216	$7.50	_____
_____	Vol. 19	"Gift of Painting" by Susan Scheewe	230	$7.50	_____
_____	Vol. 20	"Simply Country Watercolors" by Susan Scheewe	257	$7.50	_____
_____	Vol. 21	"Simply Watercolor" by Susan Scheewe	260		_____
_____	Vol. 2	"Keepsake Sampler" by Scheewe/Stempel	167	$6.50	_____
_____	Vol. 3	"Keepsake Sampler" by Camille and Susan Scheewe	173	$6.50	_____
_____	Vol. 4	"Keepsake Sampler" by Camille and Susan Scheewe	200	$6.50	_____
_____	Vol. 1	"Painting, It's Our Bag" by Bev Hink/Sue Scheewe	193	$7.50	_____
_____	Vol. 2	"Painting, It's Our Bag" by Bev Hink/Sue Scheewe	209	$7.50	_____
_____	Vol. 1	"Loving You" by Susan Scheewe and Camille Scheewe	244	$7.50	_____
_____	Vol. 1	"Western Images" by Becky Anthony	186	$6.50	_____
_____	Vol. 3	"Fantasy Flowers II" by Georgia Bartlett	129	$6.50	_____
_____	Vol. 5	"Soft Petals" by Georgia Bartlett	171	$6.50	_____
_____	Vol. 6	"Painting Fantasy Flowers" by Georgia Bartlett	215	$7.50	_____
_____	Vol. 1	"Painting, A Barrel of Fun" by Donna Bell	194	$6.50	_____
_____	Vol. 2	"Painting, A Barrel of Fun" by Donna Bell	201	$7.50	_____
_____	Vol. 3	"Barnscapes and More" by Donna Bell	218	$7.50	_____
_____	Vol. 4	"Countryscapes" by Donna Bell	249	$7.50	_____
_____	Vol. 1	"Kids and Water" by Joyce Benner	234	$7.50	_____
_____	Vol. 1	"Natures Palette" by Carol Binford	248	$7.50	_____
_____	Vol. 1	"Oil Painting The Easy Way" by Bill Blackman	219	$7.50	_____
_____	Vol. 1	"Mini Mini More" by Terri and Nancy Brown	150	$6.50	_____
_____	Vol. 2	"Mini Mini More" by Terri and Nancy Brown	151	$6.50	_____
_____	Vol. 4	"Heritage Trails" by Terri and Nancy Brown	169	$6.50	_____
_____	Vol. 1	"Windows of My World" by Jackie Clafin	174	$6.50	_____
_____	Vol. 2	"Windows of My World" by Jackie Clafin	181	$7.50	_____
_____	Vol. 3	"I'm Partial To Flowers" by Ellie Cook	157	$6.50	_____
_____	Vol. 4	"Enjoy Watercolor" by Ellie Cook	210	$7.50	_____
_____	Vol. 5	"Celebrate The Moments With Watercolor" by Ellie Cook	227	$7.50	_____
_____	Vol. 6	"Watercolor Memories" by Ellie Cook	246	$7.50	_____
_____	Vol. 1	"Santa and Sams" by Bobi Dolora	258	$7.50	_____
_____	Vol. 1	"Expressions In Oil" by Delores Egger	154	$6.50	_____
_____	Vol. 2	"Expressions In Oil" by Delores Egger	164	$6.50	_____
_____	Vol. 4	"Expressions In Oil" by Delores Egger	239	$7.50	_____
_____	Vol. 1	"Victorian Days" by Gloria Gaffney	240	$7.50	_____
_____	Vol. 2	"Days of Heaven" by Gloria Gaffney	252	$7.50	_____
_____	Vol. 1	"Watercolor Made Easy" by Kathie George	190	$7.50	_____
_____	Vol. 2	"Watercolor Made Easy" by Kathie George	236	$7.50	_____
_____	Vol. 5	"The Sky's The Limit" by Jean Green	203	$6.50	_____
_____	Vol. 1	"The Way I Started" by Gary Hawk	120	$6.00	_____
_____	Vol. 1	"Roses Are For Everyone" by Bill Huffaker	145	$7.50	_____
_____	Vol. 3	"Nature's Beauty" by Bill Huffaker	177	$6.50	_____
_____	Vol. 1	"Copper, Silver, Brass and Glass" by Susan Jenkins	211	$6.50	_____
_____	Vol. 2	"Anyone Can Watercolor" by Ken Johnston	118	$6.50	_____
_____	Vol. 3	"Anyone Can Watercolor" by Ken Johnston	119	$6.50	_____
_____	Vol. 1	"Happy Heart, Happy Home" by Cathy Jones	241	$7.50	_____
_____	Vol. 1	"Watercolor Fun and Easy" by Beverly Kaiser	243	$7.50	_____
_____	Vol. 1	"Southwest Splendor" by Kathie Kessler	222	$6.50	_____
_____	Vol. 1	"Backroads of My Memory" by Geri Kisner	225	$6.50	_____
_____	Vol. 2	"Backroads of My Memory" by Geri Kisner	245	$7.50	_____

_____	Vol. 1	"Country's Edge" by Shirley Koenig	179	$7.50	_____
_____	Vol. 2	"Country's Edge" by Shirley Koenig	212	$6.50	_____
_____	Vol. 1	"Love Lives Here" by Mary Lynn Lewis	170	$6.50	_____
_____	Vol. 2	"Love Lives Here" by Mary Lynn Lewis	185	$6.50	_____
_____	Vol. 3	"Love Lives Here" by Mary Lynn Lewis	195	$6.50	_____
_____	Vol. 1	"Ducks and Geese" by Jean Lyles	172	$6.50	_____
_____	Vol. 1	"Creative Quill" by Claudia Nice	133	$6.50	_____
_____	Vol. 2	"Barnyards and Billygoats" by Claudia Nice	134	$6.50	_____
_____	Vol. 3	"Wings and Wildflowers" by Claudia Nice	135	$6.50	_____
_____	Vol. 5	"Pen and Brush Animals" by Claudia Nice	137	$6.50	_____
_____	Vol. 6	"Journey of Memories" by Claudia Nice	166	$6.50	_____
_____	Vol. 7	"Scenes from Seasons Past" by Claudia Nice	183	$7.50	_____
_____	Vol. 8	"A Taste of Summer" by Claudia Nice	223	$7.50	_____
_____	Vol. 1	"Wildflower Sampler" by Bev Norman	191	$7.50	_____
_____	Vol. 1	"Stepping Stones" by Judy Nutter	121	$6.50	_____
_____	Vol. 2	"Stepping Stones" by Judy Nutter	122	$6.50	_____
_____	Vol. 1	"Whimsical Critters" by Lori Ohlson	228	$7.50	_____
_____	Vol. 1	"Oh Those Little Rascals" by Diane Permenter	247	$7.50	_____
_____	Vol. 1	"Rustic Charms" by Sharon Rachal	175	$6.50	_____
_____	Vol. 2	"Rustic Charms II" Sharon Rachal	199	$7.50	_____
_____	Vol. 3	"Rustic Charms III" by Sharon Rachal	217	$6.50	_____
_____	Vol. 4	"Rustic Charms IV" by Sharon Rachal	238	$7.50	_____
_____	Vol. 1	"Painting Flowers With Augie" by Augie Reis	152	$6.50	_____
_____	Vol. 1	"Forever In My Heart" by Diane Richards	188	$6.50	_____
_____	Vol. 2	"Memories In My Heart" by Diane Richards	189	$6.50	_____
_____	Vol. 3	"Forever In My Heart II" by Diane Richards	205	$7.50	_____
_____	Vol. 5	"Memories In Your Heart" by Diane Richards	237	$7.50	_____
_____	Vol. 6	"Angels In My Stocking" by Diane Richards	254	$7.50	_____
_____	Vol. 3	"Southern Exposure" by Sue Sickel	221	$6.50	_____
_____	Vol. 1	"Realistic Florals and More" by Judy Sleight	233	$7.50	_____
_____	Vol. 1	"Soft & Misty Paintings" by Kathy Snider	204	$7.50	_____
_____	Vol. 2	"Soft & Misty Paintings" by Kathy Snider	229	$7.50	_____
_____	Vol. 3	"Soft & Misty Paintings" by Kathy Snider	251	$7.50	_____
_____	Vol. 2	"Creations in Canvas...and More" by Carol Spooner	256	$7.50	_____
_____	Vol. 1	"Rise & Shine" by Jolene Thompson	214	$6.50	_____
_____	Vol. 2	"Garden Gate" by Jolene Thompson	250	$7.50	_____
_____	Vol. 1	"Count Your Blessings" by Chris Thornton	176	$7.50	_____
_____	Vol. 2	"Count Your Blessings" by Chris Thornton	180	$6.50	_____
_____	Vol. 3	"Count Your Blessings" by Chris Thornton	196	$6.50	_____
_____	Vol. 4	"Count Your Blessings" by Chris Thornton	206	$7.50	_____
_____	Vol. 5	"Count Your Blessings" by Chris Thornton	213	$6.50	_____
_____	Vol. 6	"Share Your Blessings" by Chris Thornton	226	$7.50	_____
_____	Vol. 7	"Blessings" by Chris Thornton	255	$7.50	_____
_____	Vol. 4	"Friends We've Known" by Gene Waggoner	187	$6.50	_____
_____	Vol. 5	"Friends Are Forever" by Gene Waggoner	231	$7.50	_____
_____	Vol. 1	"Fantasy Folk" by Don Weed	123	$6.50	_____
_____	Vol. 2	"Painting The Clowns" by Don Weed	124	$6.50	_____
_____	Vol. 4	"Daydreams & Sweet Shirts" by Don & Lynne Weed	198	$7.50	_____
_____	Vol. 5	"Daydreams & Sweet Shirts II" by Don & Lynne Weed	208	$7.50	_____
_____	Vol. 1	"Friendship Garden" by Shirley Wingert	253	$7.50	_____
_____	Vol. 1	"Colored Pencil Made Easy" by Jane Wunder	232	$7.50	_____
_____	Vol. 2	"Colored Pencil Made Easy" by Jane Wunder	242	$7.50	_____
_____	Vol. 3	"The Beauty of Colored Pencil and Ink Drawing" by Jane Wunder	259	$7.50	_____
_____	Vol. 1	"Something Special For Everyone" by Mildred Yeiser	158	$6.50	_____
_____	Vol. 2	"Something Special For Everyone" by Mildred Yeiser	178	$6.50	_____
_____	Vol. 4	"Something Special For Everyone" by Mildred Yeiser	235	$7.50	_____

Many art and craft supply stores carry the materials used in the television series and throughout the book. If you are having trouble locating materials such as the foliage brush, sponges, brush holder/water container, palette, paint, graphite Saral or any other materials I have used; please feel free to write or call us at: Susan Scheewe Publications, 13435 N. E. Whitaker Way, Portland, Or. 97230. Telephone (503) 254-9100, FAX (503) 252-9508.

Add $1.75 for first book for packing and shipping.
Add $1.25 per each addtional book.
U.S. Currency
Prices subject to change without notice.

SHIPPING_____

BOOK TOTAL_____

TOTAL_____

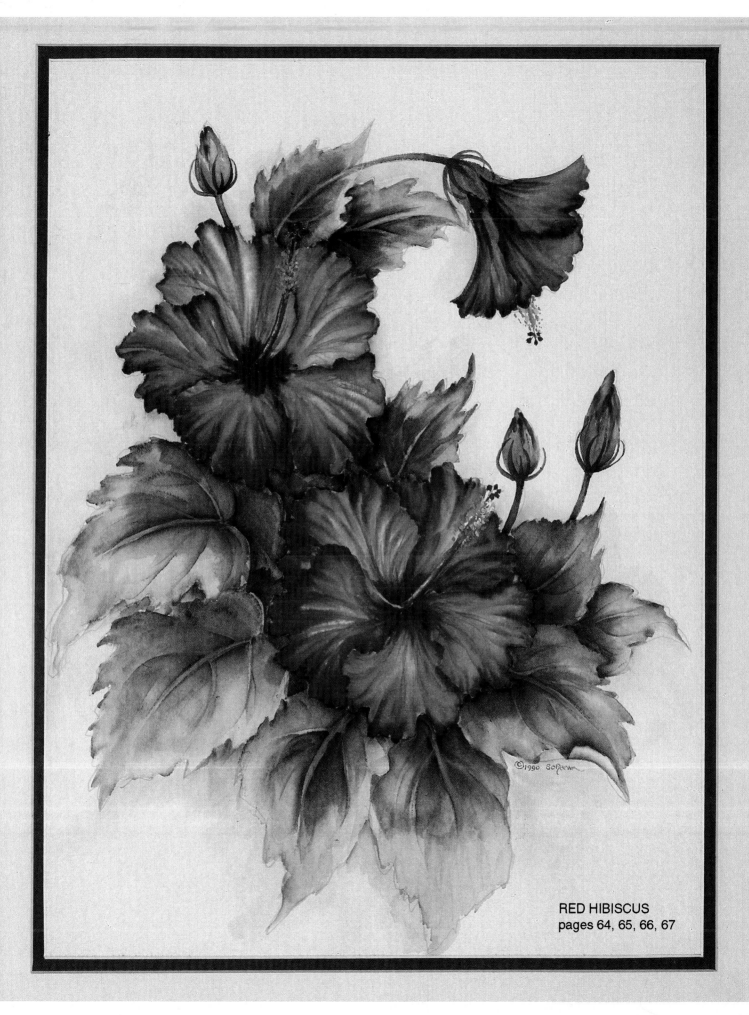

RED HIBISCUS
pages 64, 65, 66, 67

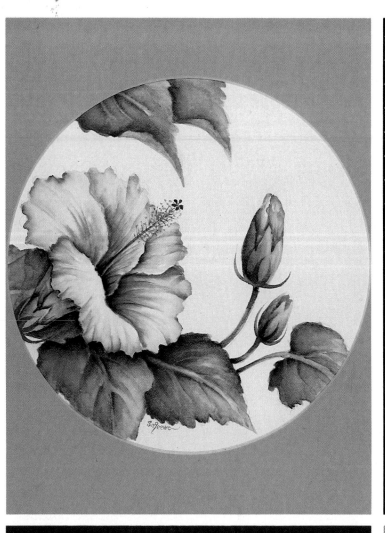

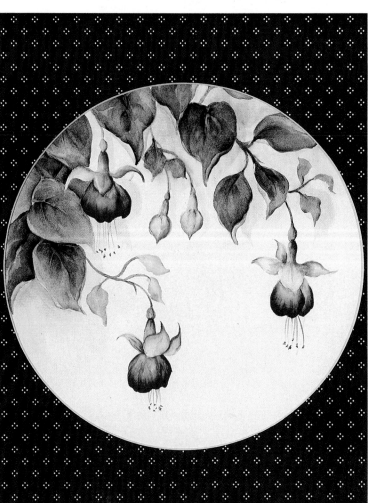

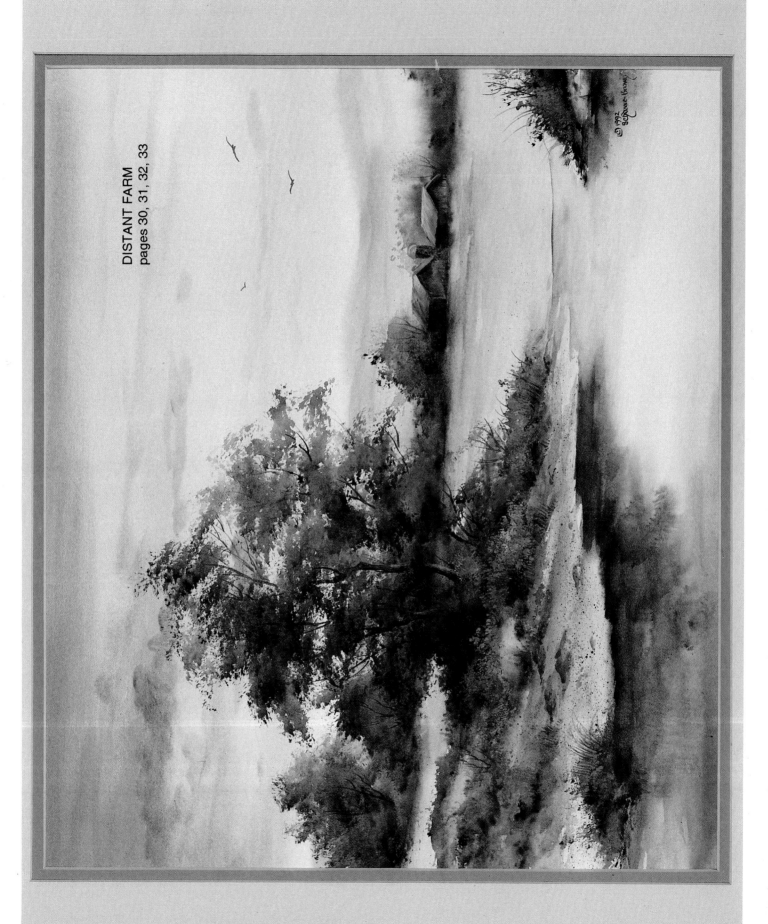

DISTANT FARM
pages 30, 31, 32, 33

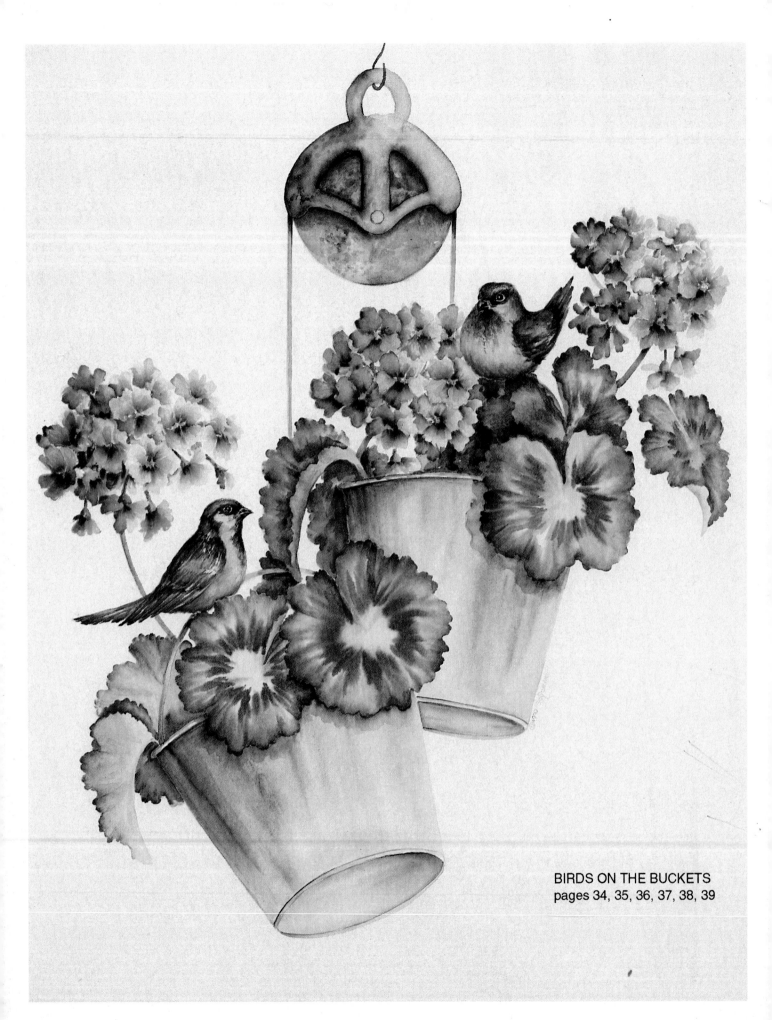

BIRDS ON THE BUCKETS
pages 34, 35, 36, 37, 38, 39

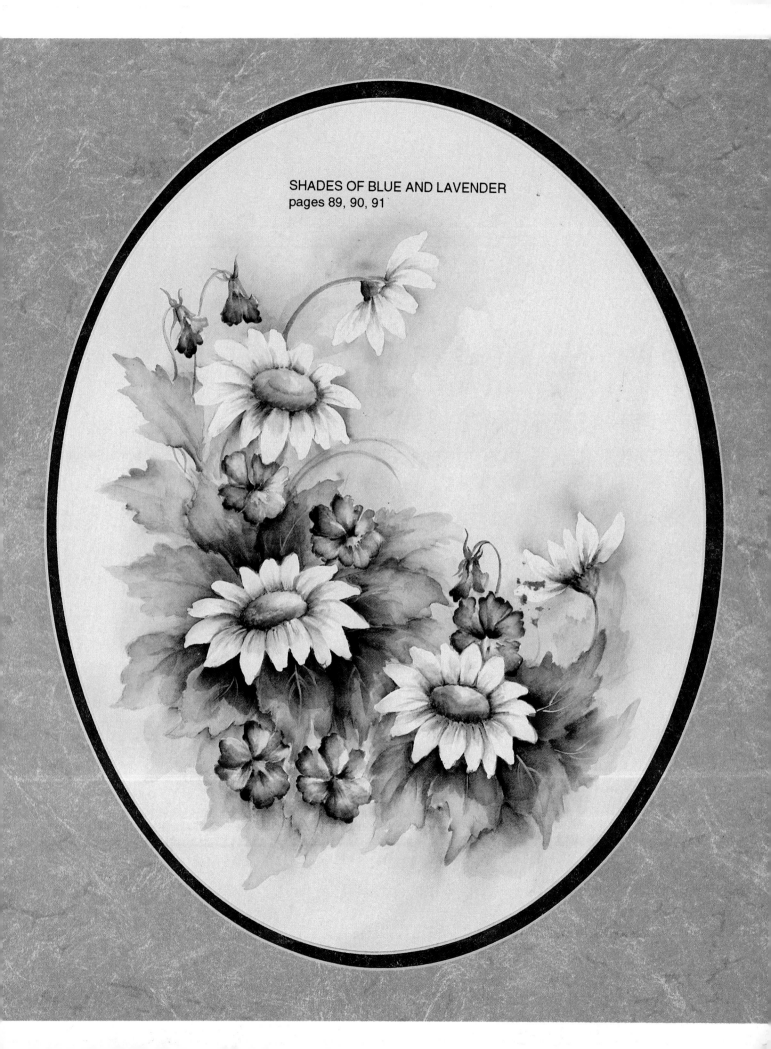

SHADES OF BLUE AND LAVENDER
pages 89, 90, 91

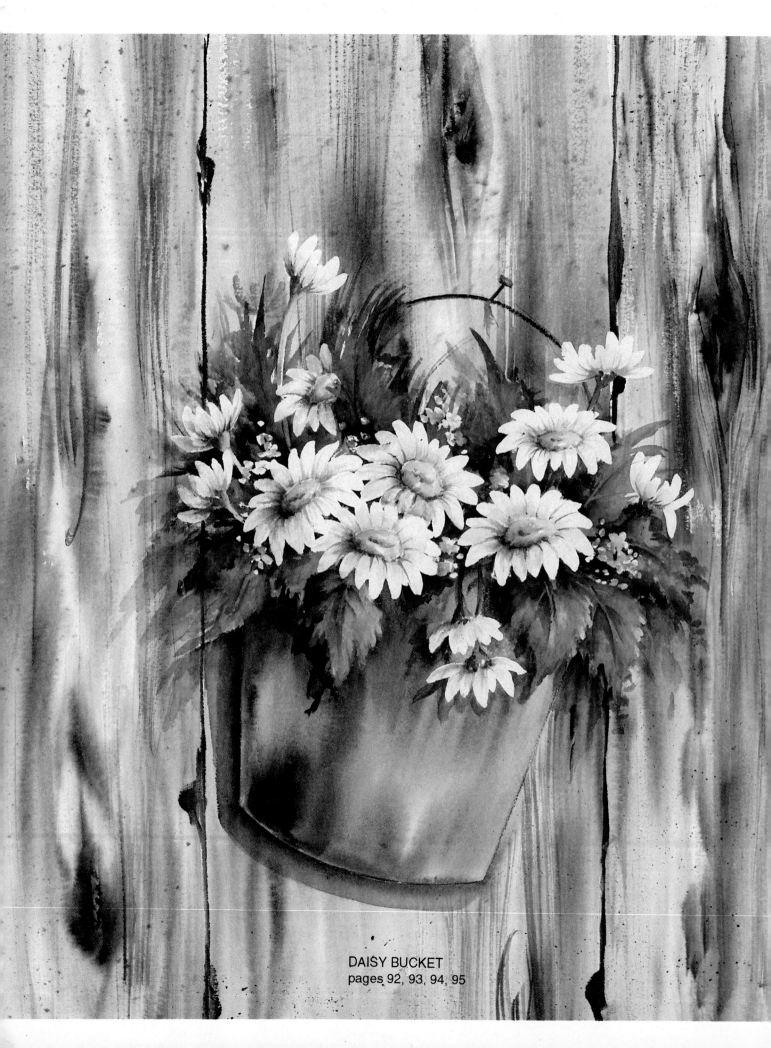

DAISY BUCKET
pages 92, 93, 94, 95